# LEARN
# LETTERING
## AND
# CALLIGRAPHY
## STEP·BY·STEP

# LEARN
# LETTERING
## AND
# CALLIGRAPHY
## STEP·BY·STEP

Gail and Christopher Lawther

Calligraphy by
**Anne Trudgill**

Macdonald

A MACDONALD BOOK

© Diagram Visual Information Ltd 1986

First published in Great Britain in 1986
by Macdonald & Co (Publishers) Ltd
London & Sydney

A member of BPCC plc

British Library Cataloguing in Publication Data
Lawther, Christopher
    Learning lettering and calligraphy step-by-
    step.
    1. Calligraphy
    I. Title    II. Lawther, Gail
    745.6'1    Z43

ISBN 0-356-12458-4

**The Diagram Group**

| | |
|---|---|
| Designer | Philip Patenall |
| Editor | Reet Nelis |
| Calligrapher | Anne Trudgill |
| Artist | Graham Rosewarne |
| Contributors | Sally Berger, Alison Chapman, Anya Scott |
| Art staff | Joe Bonello, Richard Czapnik, Alison Goodhew |
| | Brian Hewson, Richard Hummerstone |
| Acknowledgements | Grateful thanks are due to the following for permission to reproduce their work: Arthur Baker, Alan Blackman, Robert Boyajian, Hans-Joachim Burgert, Gaynor Goffe, John Fitzmaurice, Peter Good, Roger Kohn, the Mansell Collection, Ieuan Rees. |
| | Every effort has been made to acknowledge sources but we apologise for any omissions that may have occurred. |

Filmset by Bournetype, Bournemouth
Printed and bound by Toppan Printing, Singapore

Macdonald & Co (Publishers) Ltd
Greater London House
Hampstead Road
London  NW1 7QX

# Foreword

Anyone can do attractive lettering. You don't have to use a quill pen on vellum or parchment; good lettering is a technique that can be learnt through careful observation and practice of some basic principles.

You've probably been put off by the mystique surrounding calligraphy. You may look at your own handwriting and wonder how it can possibly be turned into fine lettering! But don't be discouraged; lettering, like any new skill, can be learnt in easy stages.

Good lettering is a matter of concentrating on detail. In this book you'll learn how to recognise different styles of writing by their basic characteristics and shapes. Then you'll learn how to reproduce these details so that your own attempts look authentic from the very beginning. You'll see how to lay out the lines of lettering on a page, and how to decorate the final product to add that finishing touch. But all of this you can take at your own pace.

You don't need a lot of expensive equipment to do good lettering; a few good pens, some pencils and a ruler will be fine to start with. This book will show you how easy it is to master the basics of all styles of calligraphy, even the ones that look the hardest, just by putting into practice the principles of good lettering. You can start off on easy projects – a gift label or a place-card – and then learn to apply your lettering skill to making your own stationery, certificates, maps, monograms or greetings cards.

You won't believe how easy and enjoyable it is to do good lettering and calligraphy!

# Contents

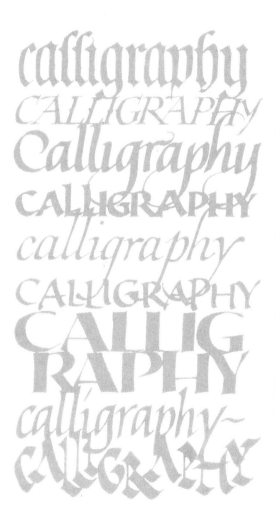

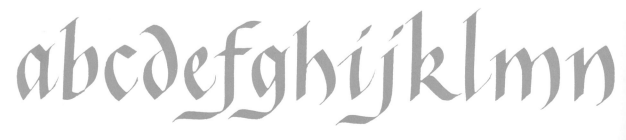

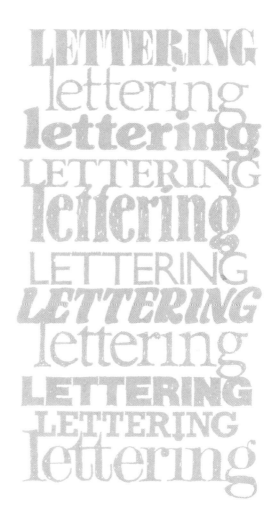

opqrstuvwxyz&

©DIAGRAM

# Part One

# AN INTRODUCTION TO LETTERING

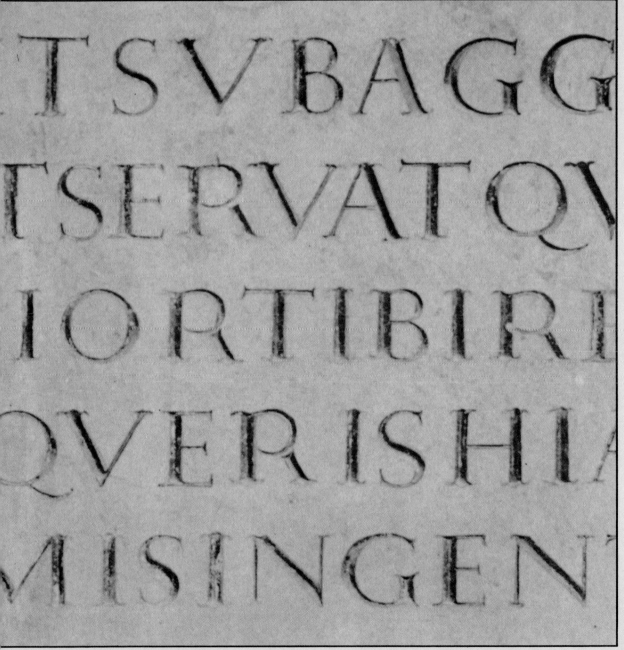

# A *brief history of lettering*

Letterforms have a long and diverse history; even the fairly standard shapes that we use in western alphabets have been through numerous changes of style and emphasis. These days lettering design is one of the most intriguing and fluid branches of graphic design; modern technology has meant that typefaces can be altered, augmented and elaborated upon in countless ways, sometimes at the push of a button. This doesn't mean that calligraphy – hand lettering – has died. The contemporary habit of looking on lettering as an art form has given the calligrapher more scope than ever before to be inventive and original. However, it's still useful to look at the styles of lettering that have led us up to the present day, because different features in the history of western letterforms help us to understand some of the characteristics of today's styles as well as helping us to grasp the basics of good lettering.

## Origins

We can trace the origins of our present-day western alphabets back over 3000 years to the 22 letters of the Phoenician alphabet, which was adopted and adapted by the Greeks and then taken up and remodelled into the Roman forms of the 1st century AD. Since then, despite changes in lettering surfaces – stone, papyrus, vellum, parchment, paper or VDU – and writing tools, such as chisel, brush, reed pen, quill, steel-nibbed pen, ballpoint pen or even character-generating computers, today's capital alphabets would be instantly recognisable to a citizen of 1st-century Rome.

And yet, not surprisingly, the last 2000 years have seen a near-infinite variety of lettering styles within the basic pattern of the Roman form. Many of these make beautiful models or sources of inspiration for calligraphy today, for use in handwriting, decorative work, texts, menus, verse, posters, handbills, books, invitations, and so on, or for complementing illustrations or photographs.

## Early Roman forms

One major reason that the classic Roman monumental letter, or square capital, was so important was because of the strength and spread of the Roman Empire. The scope of its trade and government, requiring good and quick communication among the different points, meant that

Part of a Phoenician inscription of the 9th century BC.

Fragment of a Roman inscription from Northern Italy.

10

writing was extremely important. Many examples of the use of lettering in Roman times can be seen today throughout Europe – triumphal arches boasted of conquests by emperors; buildings had dedications and inscriptions; statues and memorials told stories of heroes and battles and public notices (and even graffiti!) were brush-lettered on walls.

The Roman Empire was a highly literate civilisation, and quickly developed the need for a variety of scripts for different purposes. The majuscule or capital alphabet continued but the square capitals, though they were very well suited to inscription work and formal texts, were not quick or easy to write. At this time the main writing tools and materials were a square-ended reed pen for papyrus, or an iron or metal stylus for writing on wax tablets. Neither combination made it very easy to imitate good inscriptional capitals.

### Rustica – a less formal style

To meet the need for speed in writing and for a letterform that was more suited to the common writing implements, less formal styles of writing emerged. Rustica became the most frequently used style for book writing. It was a compressed form that was more economical on space (and, therefore, on precious writing materials) as well as being quicker to execute. Ironically it was copied on stone in some inscriptions, although it was not at all easy to cut accurately.

Rustica stayed dominant until the fall of the Roman Empire, but even after that it surfaced again and again as a decorative hand or a chapter opening style well into the 10th century. There were other scripts evident during this time, mainly everyday informal hands showing 'cursive' capitals, quickly written as we would write notes or informal correspondence today.

### Emergence of Uncial forms

The main form that succeeded both square capitals and Rustica was the Uncial style, and later the Half-Uncial. By the 4th century parchment and vellum were being used for more formal documents and literature, and the quill pen was becoming more common than the reed pen. The quill allowed the scribe to execute a finer script, and the pen's flexibility gave him more variation in modelling the strokes of the letters to different

Part of an inscription in the Forum in Rome.

Graffiti on a wall at Pompeii painted in the 1st century AD.

An example of Rustica from 4th or 5th-century Italy.

QuInTuSbum
LITATISGRADUS
EST SIOMNES.

A 7th-century example by an
Anglo-Saxon scribe (*top*).
Roman Half-Uncial written in
the early 8th century (*above*).

An example from a 9th-
century Tours manuscript.

widths. To an extent, Uncial can be seen as a refined
version of the cursive Roman capitals. As this style
developed, the Roman Empire adopted Christianity, and
so Uncial became the main hand for the vast amount of
copying of gospels, epistles and other Christian material.
This made sure that various lettering styles based on the
Uncial form spread throughout Europe.

Once again, probably because of the need for speed,
another variation in style developed: the Half-Uncial.
This is the precursor of our minuscule (small or
lower-case letters), where for the first time primitive
ascenders and descenders outside the height of the
capital letters were being formed. Monasteries and
scholastic or clerical institutions kept this basic form for
the next few centuries, but, with no central authority
after the Roman Empire had broken up, each country
developed its own form. This led to a proliferation of
what we can see clearly as insular or national hands for
different countries. The gospel books of Kells and
Lindisfarne show what are perhaps the heights of the
Uncial and Half-Uncial letterforms, with a great deal of
embellishment and ornamentation.

**A new style for Europe – Carolingian minuscule**
By the end of the 8th century a strong leader,
Charlemagne, took control of much of Europe. He was
the first king of the Franks, and the Holy Roman
Emperor. He took an interest in establishing a consistent
script throughout his territory; by that stage a wide
range of forms existed, some of them recognisable as
Uncials or Half-Uncials but with others showing a
strong tendency towards complete alphabets of capitals
and small letters. Charlemagne instructed Alcuin of
York to study contemporary scripts and writings at his
monastery in Tours, and to establish a standard form.

As a result, during Charlemagne's reign the
Carolingian minuscule became the dominant form. This
was the first true minuscule hand, with long 'clubbed'
ascenders and descenders, requiring four guide lines to
write it rather than the two that were necessary for
capital letters. Here was a new formal book hand that
was to influence Europe for the next two or three
centuries, and which later was to have an even more
far-reaching effect at the time of the Italian Renaissance.
Most historians of letterforms point to the development

of the Carolingian minuscule as the most significant letterform since the formal Roman alphabet, and its influence today can be seen in all written and printed matter.

One significant feature that the Carolingian minuscule lacked was a capital form in the same style. At the time the Roman square capital tended to fill the gap, and manuscripts of the time show various other letterforms as well. The Rustica still survived for some small headings or for emphasis; Uncial and Half-Uncial were often used for introductions or headlines at the top of a page to tell the reader which section he was in. Missal Versals – letterforms that were built up from several strokes rather than one – were often the basis for large capitals, richly ornamented, in illuminated manuscripts. Books of this period had a very free form in their basic structure of columns, with a mixed influence of capital styles coupled with gilding, line decoration and painted illuminations.

An example of Carolingian minuscule from the 9th century.

## The Black Letter

The Middle Ages saw a proliferation of manuscripts and documentation of all kinds – the beginning of bureaucracy? Legal, business, education and general administrative work such as business accounts, household book keeping, and so on, meant that lay people tended to take the initiative in writing styles away from the monastic houses and court scribes. Once again the need for increased speed and economy in valuable writing material led to a gradual move away from the roundness and the long ascenders and descenders of the Carolingian minuscule to a letterform that was more angular, condensed, and dense on the page. This style is known as the Gothic or Black Letter. The style had a variety of forms, influenced by the different regions using them, but all of them were made in the same way, with a broad-nibbed pen held slanted at an angle. Some of the forms are very distinct; for instance *textura quadrata* is easy to identify from its diamond-pointed feet and its marked regularity. This style was favoured more in Germany and northern Europe, while Italy retained a more cursive style called Rotunda.

These were the main two styles, but there were many local variations in angularity, stress, ascender and

15th-century examples of Gothic Textura (*above*) and Rotunda (*below*).

# *a brief history of lettering*

descender height, compression, and decoration. One notable feature of this entire period however was, at last, the combination of majuscules and minuscules (capital and small letters) in the same basic style of construction. Other letterforms were still used for other purposes in manuscripts or documents, but with Black Letter the capital and lower case alphabets happily coexisted.

## The Renaissance and Humanistic influences

The term Renaissance means 'rebirth', and the Italian Renaissance can be seen as an intellectual rebirth of an interest in antiquity, especially an interest in the Roman Empire and its artistic and architectural achievements. Not surprisingly, one element of this was a revival of interest in the plethora of inscriptions of all sorts, surviving especially in Rome and Florence and their environs. These were studied intensely and became models for Renaissance-period inscriptions, such as in the interior of St Peter's in Rome, or on the front of the SS Maria Novella in Florence. One of the main models was the tribute to Agrippa on the front of the Pantheon in Rome.

Soon all manner of treatises on the Roman letter came out. Damianus Moyllus published the earliest in about 1480; Fra Luca de Pacioli wrote *De Divina Proportione* in about 1483 and printed it in 1509, and in 1525 Albrecht Dürer contributed a work on 'the just shaping of letters'. These men were not so much letterers as theorists, and part mathematicians, who went to great lengths to find an alphabet of fixed and 'perfect' proportions for construction with rules, curves and compass. The Renaissance men therefore created the classical theory of lettering – one the Romans themselves perhaps would never have wanted to formulate.

The findings of these men naturally influenced writing styles, especially in southern Europe, and the Roman capitals became popular again. Obviously for the more developed ideas of writing a minuscule form was required too, and the humanist scholars of the time looked for their idea of an antique or classic form; they seized on the Carolingian minuscule and renamed it *littera antiqua* – old, or antique, letterform. Though the Gothic style remained supreme further north, in other regions a succession of rounder, more cursive (at times

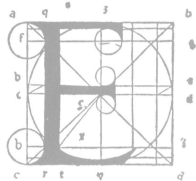

Illustration from a 16th-century Italian manual on writing.

Part of Niccolo Niccoli's 15th-century *littera antiqua* (*below*) and an example of 15th-century Humanistic writing (*bottom*).

positively florid) 'Humanistic scripts' emerged, based on the Carolingian model. These variations included a chancery cursive, or cancellaresca, and another cursive which was the first full italic form. Writing masters abounded, competitively showing off their skills in samples and writing manuals for others to copy.

The styles of the Italian Renaissance have produced the most profound impact on European society as their supremacy coincided with the advent of the printing press. Although the first books by Johannes Gutenberg, Johannes Fust and Peter Schoeffer, used the Black Letter as their type model, as the centre of printing moved south first the Rotunda form was adapted to type. Then, by the end of the 15th century, presses such as the Aldine Press of Aldus Manutius made beautiful adaptations of both Carolingian and Italic scripts, models copied by type designers ever since.

## The influence of copper engraving

In the middle of the 16th century the *intaglio* method of printing via engraved copper plates became common. This allowed much finer quality of line than woodcuts, the previous way of reproducing illustrations and drawn letterforms. The engraver used a fine, pointed burin as his tool which could produce a fine gradation in line thickness and also suited freer strokes and ornamentation. At first the technique was needed to reproduce and copy the writing masters: after a while, though, the writing masters themselves had started imitating the initiative of the engravers and their burins with their own quill pens. The subtler broad pen Italics and the early Humanistic scripts started to give way to what is known as copperplate or Roundhand.

The quill, and later on the steel-nibbed pen, responded to the pressures of the writer's hand. This varying pressure led to a subtle swelling and narrowing of line. The basic copperplate alphabet was a fairly straightforward cursive script, allowing for speed of writing; the pen generally remained on the paper except for word breaks and punctuation. The character came from the swelling of the strokes and from loops and decorations – taken to extremes in many cases, where effect took over from legibility. However, in its simpler forms copperplate has an elegance and rhythm that is very attractive.

An example of G. B. Palatino's cancellaresca style.

The first Italic type by Aldus Manutius.

An 18th-century Portuguese example of copperplate.

©DIAGRAM

15

# a brief history of lettering

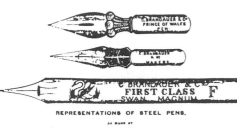

REPRESENTATIONS OF STEEL PENS.
AS MADE BY

C. BRANDAUER & CO.

Manufacturers of Steel Pens of every description,

NEW JOHN STREET PEN WORKS,

BIRMINGHAM.

Detail of type from one of William Morris' Kelmscott Press books.

IS THE NIGHT WORN
he time appointed, for it was
hours after midnight, so
stepped out of his tent clad
all his war gear, and went
aight to the doddered oak,
found Redhead there with
one horse, whereby Ralph

Lettering by Edward Johnston based on historic Uncial.

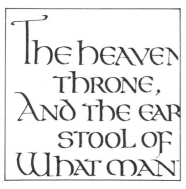

The heaven
Throne,
And the ear
stool of
What man

## Introduction of steel pens

Throughout the 18th and 19th centuries copperplate remained the main script, and no significant new style emerged. Change was more evident in the writing implements themselves, with the introduction of steel-nibbed pens in a variety of forms. Whether this was an invention of the French, British or Americans is uncertain, but certainly by 1830 Birmingham in England had a successful industry based on pen production. At first the handmade metal pens were expensive, but soon factories were producing them by machine very cheaply indeed. With better paper and ink, as well as improved pens and greater literacy, writing was far less an art form than a necessity. The Industrial Revolution brought about more and more clerical jobs and similar posts where speed and neatness in writing counted for more than ornamentation. Schools taught formal copperplate for the new pens, and for the first time generations of children grew up regarding the ability to write as the norm rather than as something for the odd few.

## Arts and Crafts – a calligraphic revival

A new movement or reawakening to older calligraphic models came about in England towards the end of the 19th century. The Arts and Crafts Movement was a reaction to the mass-production of the industrial scene, a call for a return to 'honest' handmade craftsman-produced objects. One of the main instigators of the movement was William Morris. Something of a Renaissance man himself in his all-round abilities, he studied early manuscripts and printed books as well as designing and making furniture, fabrics, stained glass and the like. He took a great interest in letterform design, designing his own typefaces and setting up the Kelmscott Press, often combining his type with decorative woodcut borders. The impact of his personality and the Arts and Crafts Movement in general was so great that calligraphy came to be reconsidered as an art form and worthy of study again in artistic circles.

In Britain the next step of importance came with the publication of Edward Johnston's *Writing and Illuminating and Lettering* in 1906. Johnston discussed numerous past and present forms of lettering and encouraged the practice of calligraphy. He rediscovered the beauty of the Carolingian forms, the Humanistic

writings of Ludovico Arrighi and Giovanni Francesco Cresci, the decorative missal Versals and the Lombardic forms, and used them himself in handwritten manuscripts and books. At the same time Rudolph Koch reawakened an interest in lettering and calligraphy in Germany. He was interested in using letterforms in various media – wood, metal, fabric, glass, stone – and he used his talents too in type design.

While Johnston and Koch brought formal calligraphy back to the fore in artistic circles, Alfred Fairbank can be singled out for his influence on the everyday handwriting style. His handwriting manuals took the Humanistic italic as a suitable model for the new pens, and it was taken up in many schools around the world. Societies of Italic handwriting and similar organisations have been established and helped greatly in keeping alive an awareness of the beauty of these forms.

## Conclusion

Today in the western world we have got a high rate of literacy, but not many people are aware of the main threads of lettering history. Also we have a very wide choice of writing implement – fountain pen, ballpoint, felt-tipped pen, coloured pencil, etc. Often we grab the nearest tool without wondering whether to adapt our writing style to get the best out of each kind of implement. Formal writing is in decline as our technology has introduced faster typewriters, word processors, dictaphones and shorthand. Many business people probably only write their names on cheques and letters, and maybe the odd note in a diary; many children are now as familiar with a computer terminal as with a pen.

And yet at the same time calligraphic pensets, special papers and classes on calligraphy abound as people rediscover the joys of beautiful writing, perhaps as a reaction to the impersonal nature of the computer age. In the modern world there is a wealth of styles to look back on, copy, adapt, take on further and enjoy, while creating something beautiful in the process. Let's hope that more and more people discover the beauty and power of good lettering, and the sheer exhilaration of producing a superb piece of calligraphy.

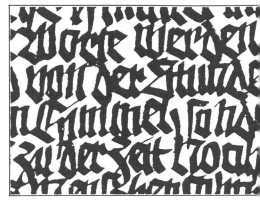

Extract from a manuscript written by Rudolph Koch in 1921.

Extract from one of Alfred Fairbank's practice writing cards.

© DIAGRAM

17

# Part Two

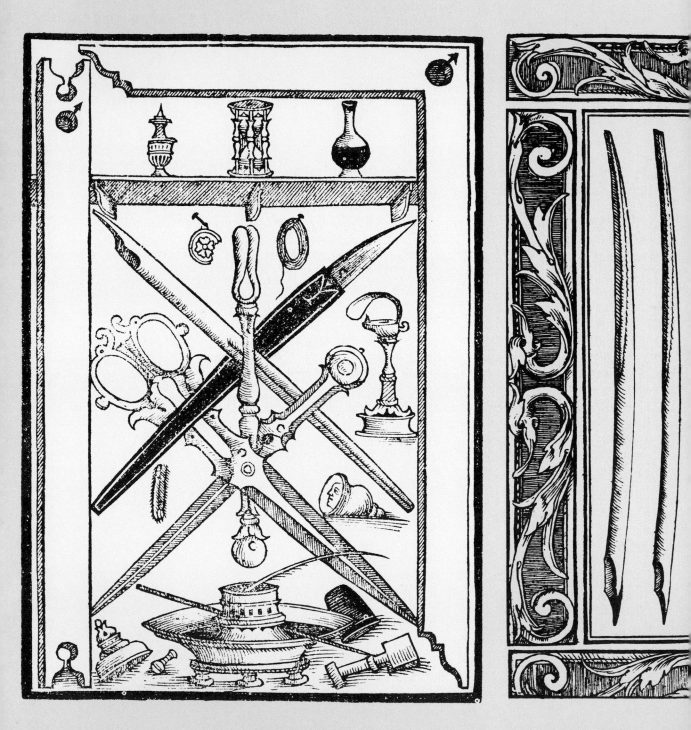

# MATERIALS

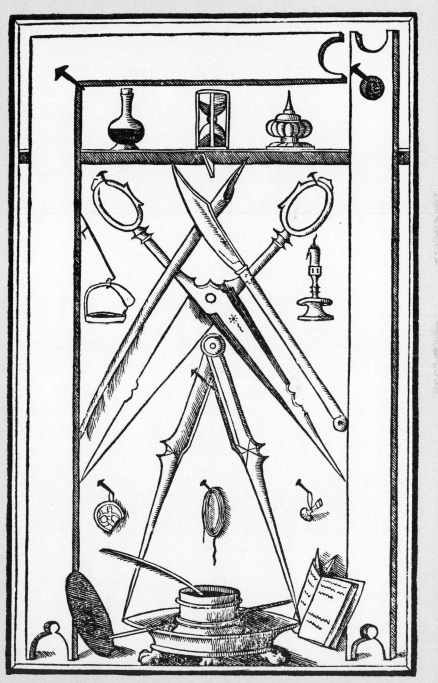

# Papers and general instructions

The word paper comes from the word papyrus, the plant used by ancient Egyptians to form a writing surface. The stems of this plant were woven together, softened, then beaten and smoothed to make a relatively smooth surface that could take the imprint of a crude pen. Today, paper is still made from plant fibres that have been softened and then pounded into flat sheets. The poorest quality paper is made mostly from wood fibres, but the very finest papers are made from virtually 100% 'rag' fibres of linen. Paper is available in many different textures and finishes. The basic texture of the paper will be determined by the process used to make it; machine-made papers have the fibres mainly in one direction, and tear more easily in one direction than the other. Handmade papers have fibres lying at all angles, and are resistant to tears in all directions. They generally have fewer chemicals added during manufacture, and so their acid/alkali balance is almost neutral, which helps inks and other pigments to take to them with fewer unpredictable results. Handmade papers, however, may have textures that are unsuitable for calligraphy, as some of them are produced for painting, printing, etc. The finish will also determine the paper's texture; finishing is the process of pressing the paper between heavy rollers to smooth its surface. The only satisfactory way for you to test the texture of the paper is to try your pens out on it, so ask for some samples before buying. Choose special papers for special projects, but for practice purposes a good block of medium-weight bond white paper will be fine.

Vellum and parchment are two specialised writing surfaces – they were used long before paper was generally available. Vellum is formed from prepared calfskin, and parchment from the inner skin of sheep or pigs. For very special items of calligraphy, you will find that vellum and parchment are somewhat more durable than paper, but also they are inevitably more expensive and harder to get hold of!

**Texture**
Ask your local paper supplier for samples of different papers, and also try out any that you already have around the house – art papers, printing papers, watercolour papers, newsprint, etc. You will see that on highly finished papers strokes can be made with very clear, definite edges (**1**). Some papers are even coated with a very fine layer of china clay, which literally produces a glazed surface which is very smooth for writing. As the paper texture becomes rougher, this starts to eat into the fine edges of your calligraphy (**2** and **3**).

## Equipment

You don't need elaborate equipment for calligraphy. A simple drawing board (**1**) provides a good flat area that can be tilted to make lettering easier; a parallel motion bar (**2**) will make drawing guide rules infinitely easier. Masking tape (**3**) can be used to hold a piece of work in place, and a spare sheet of paper should be held over the rest of the working sheet (**4**) so that your hand doesn't spoil the surface of your paper. A good diffusing light should be fixed so that it casts a clear light over your working surface (**5**) and so that your work is not shaded by your hand when you are lettering.

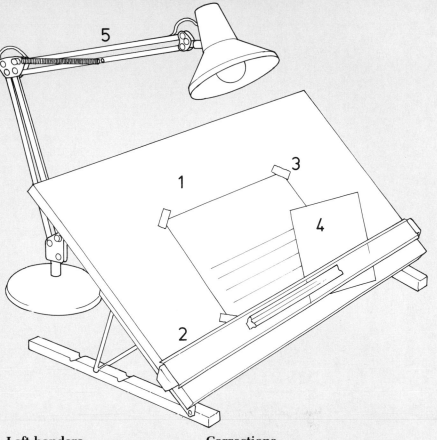

## Writing angle

Different lettering styles require different writing angles; these may be measured from the vertical line or the horizontal (**1**). The angle refers to the angle made between the flat of the nib and one of these lines; for instance in (**2**) the writing angle is 60° from the vertical, or 30° from the horizontal.

## Left-handers

Left-handed writers often find the required strokes difficult to make. Try changing your grip so that your thumb is parallel with the barrel of the pen (**1**). If this seems impractical, turn your paper to the left; this moves your hand away from your body and gives you more movement (**2**). Also, special left-handed nibs can be bought for letterforms such as Italic.

## Corrections

If you are doing lettering on special paper, you will need to know how to correct any mistakes. Even the best calligraphers make the occasional error! The wrong area can be gently scraped or sliced off with a razor blade (**1**) and the surface refinished with a burnisher (**2**). Artwork for the printer can be tidied up with typing correction fluid or process white paint.

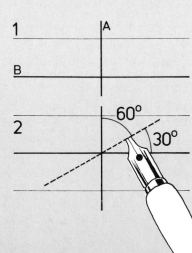

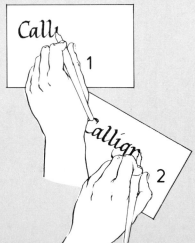

©DIAGRAM

# Pens

The very first pens designed for use with a primitive pigmented ink were the reed pens used in ancient Egypt, Greece and Rome. After these came the quill pens made from feather shafts and seen in so many old pictures and prints; these were used for centuries until the steel pen was developed in the 19th century. Once the steel nib was available very precise letterforms could be produced, and the quill lost most of its popularity – although some scribes today will still use quill or reed pens (see p 26). The types of pen and nib available nowadays can be thoroughly confusing – which ones should you choose when starting calligraphy? Basically you will want a selection of good-quality nibs of different widths to begin with; these can either be nibs attached to separate nib-holders, or intrinsic units attached to fountain pen shafts. When you begin to branch out you can try some of the other kinds of nib such as poster nibs, copperplate nibs and technical pens.

**1** Mapping nib; this can be attached to a holder, and gives a good variable line.
**2** Crow quill; this fine flexible nib is made of steel but echoes the versatility of the quill.
**3** Broad nibs in a variety of widths; these are used for producing many lettering styles such as Italic, rounded, Roman, Uncial and Half-Uncial. The broader the nib, the greater the contrast between the thick and thin strokes. The nibs may be cut square or angled.
**4** Speedball nibs; these nibs spread out into an upturned disc at the tip, which helps to distribute the ink into a wide line. The broader the disc the wider the final stroke. These nibs give lines of uniform thickness and aren't suitable for lettering styles where you need a strong contrast between thick and thin strokes.

**5** Coit and scroll nibs; these nibs are split and produce two or more lines in varying widths for extra-fancy effects.
**6** Elbow nibs used for copperplate and other rounded letterforms; the elbow enables you to hold the nib at the strong slant needed for these styles.
**7** Elbow holders with conventional nibs; this combination produces the same effect as an elbow nib.
**8** Ordinary nib-holders.

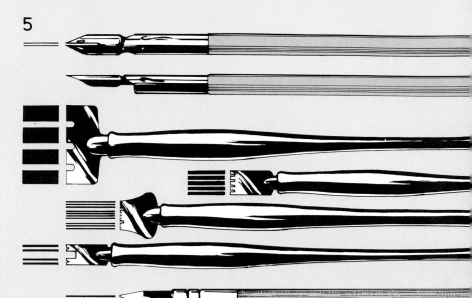

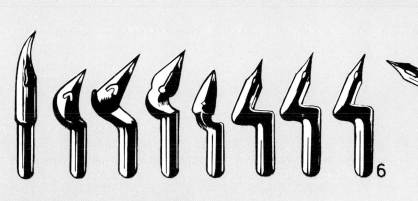

**Nib angles**
Nibs are available in various different angles to suit different purposes.
**1** Square-cut nib used by right-handed people for broad lettering strokes.
**2** Left oblique nib; this is useful for left-handers for slanted writing such as Italic.
**3** Angled nib, useful for left-handers who want to do Italic styles.
**4** Right oblique nib; useful for only a few individual styles.

© DIAGRAM

# pens

One of the main problems calligraphers face is that of keeping an even-looking ink flow throughout the lettering being produced. Dip pens hold very little ink on their own, and need to be dipped after virtually every stroke; this is time-consuming, increases the likelihood of dripping ink or smudging the work, and interrupts the smooth flow of your writing. Various systems have been developed to try to overcome these problems; experiment with the different types and see which one suits you best.

**Reservoir systems**
Some dip pens have built-in reservoir systems, or small metal reservoirs that can be slipped onto the nib shaft.
**1** Detachable reservoir.
**2** Reservoir above the nib, feeding ink down onto the writing point.
**3** Reservoir underneath the nib, keeping a supply of ink against the writing point.

**Reservoir pens**
Some pens have their own built-in reservoir in the shaft, which of course means that you can write uninterrupted for that much longer.
**1** Fountain pen; ink flows down to the nib in response to the pressure of writing.
**2** Reservoir-nib pen; here the ink is contained in a store behind the nib and its flow onto the nib is controlled by carefully angled components.
**3** Stencil-type pen; a tiny piston controls the ink flow from the reservoir.

**1** Poster pens; these very large nibs have their own built-in reservoirs.

**2** Fountain pens with interchangeable nib sections. The bottom half of the pen unscrews and can be replaced with another section holding a different nib. Most of the ordinary narrow, broad and slanted nib styles can be obtained for fountain pens. The ink supply comes from either a refillable sac or from a replaceable cartridge within the pen shaft.

**3** Automatic lettering pens; these nibs are diamond-shaped in section, and the ink is held in the diamond and spread out through the broad nib.

**4** Ruling pens; these work on the same system as the automatic lettering pens. The cavity between the two sides of the nib is filled with ink from a brush or dropper, which acts as the reservoir. These nibs can only be used for ruling or drawing circles; they are not suited to the constant change of direction when lettering.

**5** Reservoir-nib pens in different widths.

**6** Stencil-type technical drawing pens; these produce a line of uniform thickness as the ink flows out from the barrel of the pen. The tips of these pens are very delicate, so don't use them for lots of rough drawing or practising. The pens have to be held vertically to work properly.

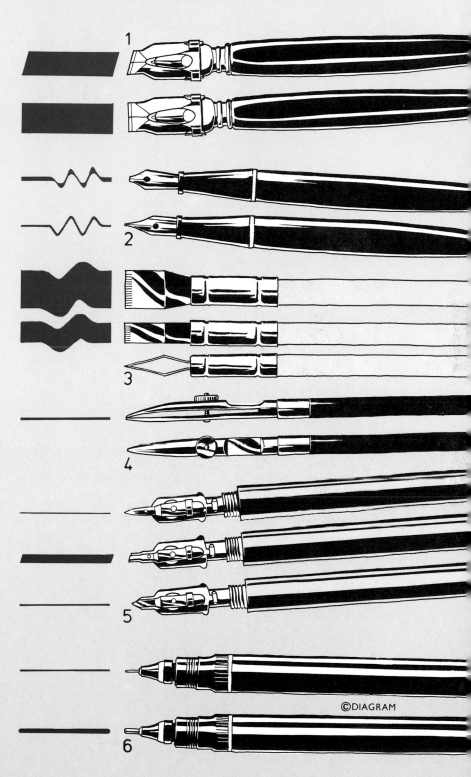

©DIAGRAM

25

# pens

Quill pens are still used by some scribes as they like the flexibility and versatility of the feather shaft; cutting your own pen also gives you the chance to cut the width and angle to your exact specifications. Feathers are readily available; the best to choose are the primary flight feathers of the swan, turkey or goose. The feather shaft will curve slightly depending on whether it came from the left or right side of the bird; left-wing feathers are best for right-handed people, and vice versa.

## Cutting a quill

The feather must have been well dried, either naturally, which will take about a year, or artificially in heat, which will clarify and harden the barrel.

**1** Shorten the plume and strip away the barbs.
**2** Cut away the tip at an angle.
**3** Make a slit in the top centre of the barrel.
**4** Cut a slice from the underside, centred on the slit.
**5** Shape the nib by cutting both sides of the slit.
**6** Make a cut across the tip of the nib at right angles to neaten it.
**7** If you want a slanted nib, trim it to the desired angle.

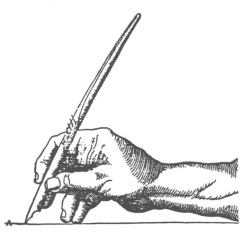

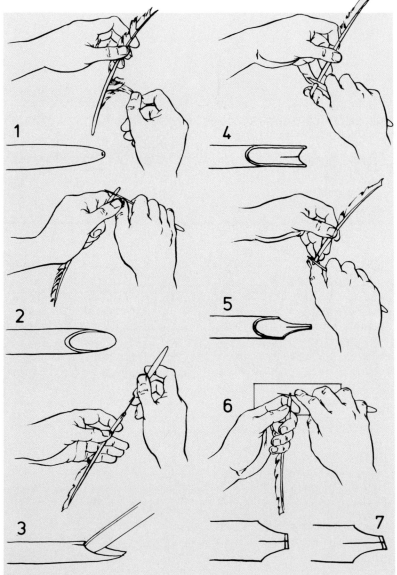

Illustration (*right*) on how to cut a quill from Wolfgang Fugger's *Handwriting Manual*, printed in 1553.

## Reed pens

Reed pens are that much more basic than quills; they don't have the same flexibility, or take such precise cuts, so they don't give such good results. However, they do have a slightly rustic quality all of their own, and they are rather easier to cut than quills, so by all means try some out for a different effect.

**1** Take a good strong, fine, dry reed and cut down as for a quill.

**2** Scrape the pith out of the centre of the reed with a sharp point.

**3** Make a second cut to form the nib properly.

**4** Cut across the tip to the desired angle.

**5** Make a slit up the centre of the nib.

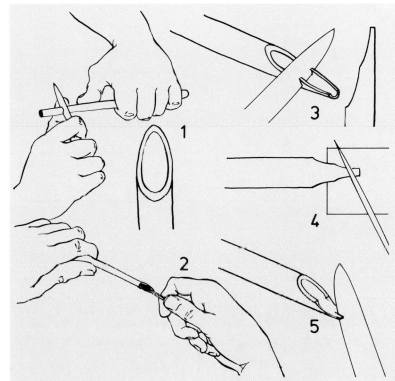

## Synthetic quills

Several attempts have been made to produce a nib that is reliable and regular but that has the flexibility of the traditional quill. These two plastic 'quills' come close to achieving the balance; you may be able to obtain similar ones to use in your penholders.

©DIAGRAM

27

# Felt pens

Felt pens, or fibre-tipped pens, may be looked down on by the traditional calligrapher, but there is no reason at all why you should not use them to produce very good lettering. The modern felt pens have a pad made of fibre which draws the ink down the barrel in a steady flow; if you buy good quality pens the fibres will stay well shaped and the ink will last quite a time.

**How felt pens work**
There are two slightly different kinds of felt pen. In the first, the hollow barrel of the pen holds the ink, which then soaks down through the fibre tip (**1**). In the second type, the fibre extends the whole length of the pen (**2**) and holds the ink within the fibres all the time; as it is used up from the tip, ink moves down to replace it from higher up the fibre column.

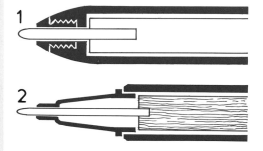

**1** Oblique-tipped pen; this can be used in the same way as an ordinary oblique nib.
**2** Wedge-tipped pens in different sizes; useful for wide lettering once you get used to the angle of the pad.
**3** Marking pens; useful for large lettering such as posters.
**4** Ordinary felt pens with tips of different widths and textures; these will give you a round-ended line.

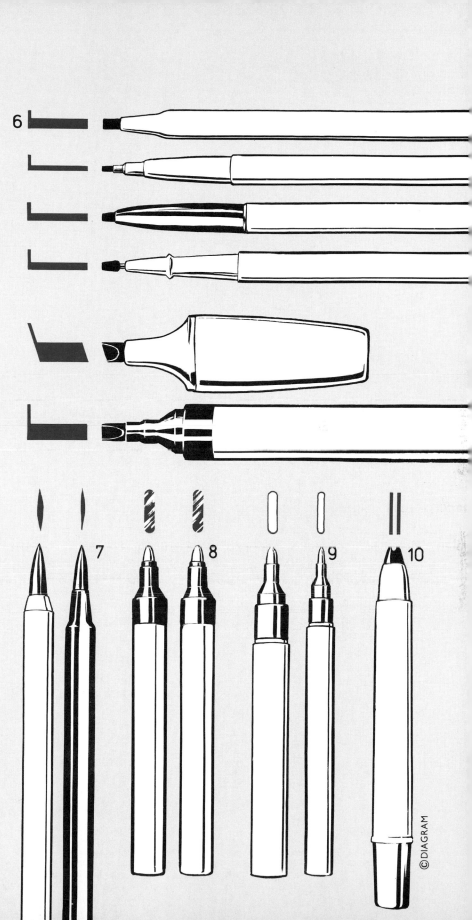

**5** Fine liners; felt pens with extremely fine points.

**6** Chisel-ended felt pens; with some of these you can produce a precise line nearly as well as with a broad-nibbed pen.

**7** Brush felt pens; the tips of these are soft and pliable, and make the tool a cross between a pen and a brush.

**8** Metallic pens; available in gold and silver.

**9** Outliner pens; these have a coloured metallic ink which separates on the paper into a thick tone surrounded with colour.

**10** Double-tipped felt pen; used to produce scroll letters and lines.

©DIAGRAM

# Brushes

Brushes may seem strange tools to include in a book on calligraphy and lettering, but as your lettering skill increases you will find that brushes add several new dimensions to your work. Firstly, lettering itself can be done with brushes – you don't need to use a pen all the time. Brush lettering has a particular knack all of its own if you seek to imitate some of the oriental methods of lettering, but you will be surprised at the ways in which you can use a brush to give a new look to conventional letterforms. Also, you will want to have a good supply of brushes ready for producing decoration of different kinds – highlighting, borders, illumination and illustrations. Many of these embellishments are much easier to work in brushes than in pens. And when you are confident enough to move on to signwriting, brushes will be far more practical as they hold much more ink than a pen and so can be used for large projects without needing to be recharged so often. You won't need a large selection of brushes to begin with; choose a representative selection from the ones shown on these pages, then you can add to your collection as you develop particular talents or interests.

1 Fine sables used for miniature work and illumination.
2 Round sables in different sizes; the long heads are useful for working the outlines of Versal letters.
3 Flat sables; these give a broader stroke.
4 Sable filbert, a wide brush with a short head.
5 Sable riggers with extra-long heads; these can be bought with square or rounded tips.
6 Ox hair brushes; larger, flatter brushes than sables.
7 Large flat; a brush used for applying colour washes to large areas.
8 Liner; useful for outlines.
9 Split-tipped brush for special effects.
10 Fitch; a brush with a deeply chiselled tip. Fitches are useful for producing large-scale versions of letterforms with a noticeable stress.
11 Square-ended brushes for producing strokes with clean ends; these are especially suitable for signwriting.
12 Quill holder and quills filled with sable hairs; these too are used for signwriting. Quills with different heads can be fitted to the holder.

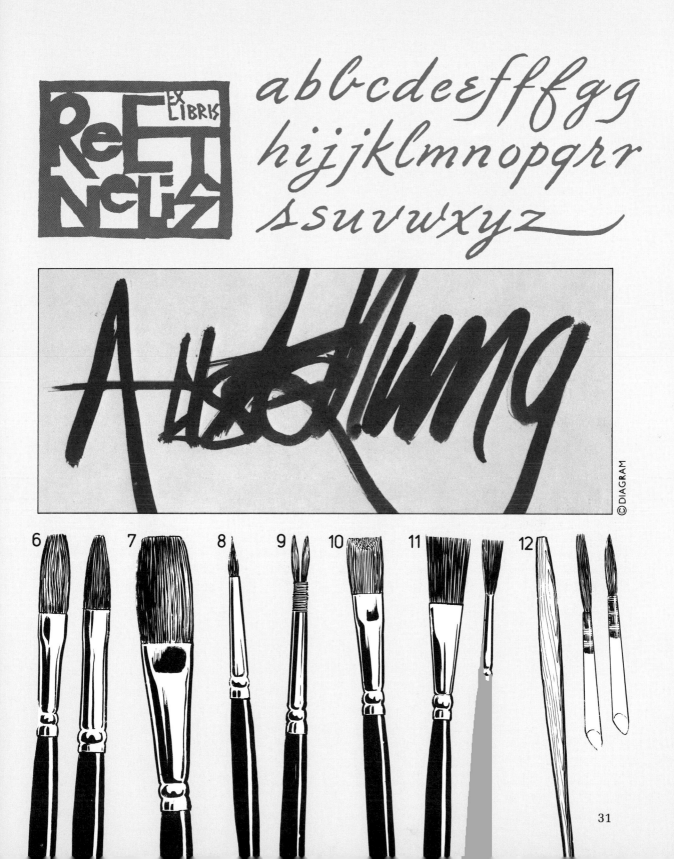

# brushes

Oriental brushes are marvellous for lettering, as they hold a large amount of ink or paint at one time but also have greater adaptability than western brushes. The brushes come in all shapes and sizes, but the characteristic that all of them display is the swelled body tapering to a very fine point; this means that the calligrapher has a wide range of effects that can be produced in a single stroke, from a very wide wash to an extremely fine line. Some of the oriental brushes are extra-long in the body; these require special manipulation, but can be used to great effect for large swirling strokes.

**1** Oriental brushes in a variety of sizes, widths and lengths of head.
**2** Ton brush for painting large oriental characters.
**3** Bamboo brush; made by crushing the fibres of one end of the bamboo until they form a soft head.
**4** Duckdown feather brush; this provides a very soft fluffy brush.
**5** Peacock feather brush; this brush is soft, but a little more versatile than the duckdown one.
**6** Bamboo mat for storing oriental brushes.
**7** Brush holders used to keep the brushes upright as they dry.

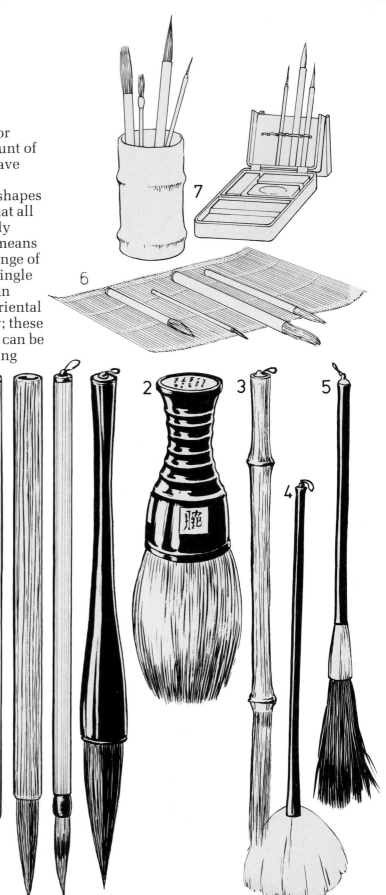

### Brush position

If you are going to do authentic oriental decorations – or even convincing looking brush calligraphy – you will need to learn to hold the brush in the correct position. The brush is held vertically to give maximum scope for manipulation, and the fingers are tucked behind the brush shaft as shown.

### Oriental brush strokes

There are three main types of stroke in oriental calligraphy and painting; the difference is in the amount of ink or paint in the brush.

**1** The wet stroke is done with a fully-loaded brush; each part of the paper touched by the brush receives a coating of ink.

**2** The medium stroke is done with a little less ink or paint; some parts of the paper, especially if the paper is heavily textured, are missed by the ink.

**3** The dry stroke looks deceptively simple but is hard to master effectively without looking like a mistake. The brush is loaded with only a small amount of ink or paint which is then drawn over the paper, leaving traces of colour here and there.

Practise all three of these strokes in your notebook until you can confidently reproduce the different effects when you want them.

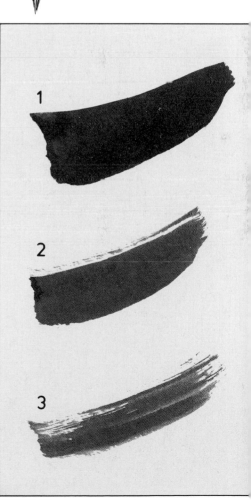

©DIAGRAM

33

# Other tools

As well as the conventional pens and brushes, calligraphy can be done with other less conventional tools. The principles of good lettering remain the same whether you are working on a tiny scale with a crow quill nib or on a large piece of board with an aerosol; remember that modern calligraphy is a very free, personal art — so make the most of some of the modern techniques!

1 Pencils in different grades.
2 Carpenter's pencil, which can be sharpened to a flat chisel point.
3 Propelling pencil with leads of varying thicknesses; these will enable you to make lines of a uniform width.
4 Crayons
5 Studio block; a large crayon lead for covering broad areas.

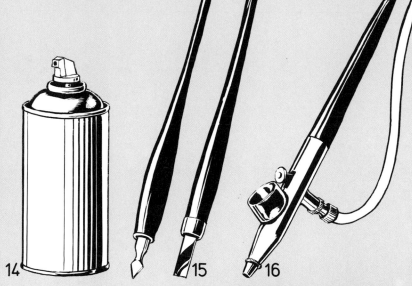

**13** Highlighter pen for covering large areas in bright colour.
**14** Aerosol can paint
**15** Scraperboard tools
**16** Airbrush; a technical tool that needs considerable practice to use properly.

©DIAGRAM

**6** Coloured leads for propelling pencils.
**7** Charcoal
**8** Charcoal pencil
**9** Chalk pastel crayon
**10** Oil pastel block
**11** Wax crayon
**12** Lacquer pen, for permanent lettering on metal, wood, etc.

# other tools

As well as the tools you actually use for lettering, you will need several back-up tools if you are going to take calligraphy seriously. Most of them are readily available and you've probably got some of them already; they are simply aids to good drawing of any kind.

**1** Masking tape for fixing your paper in place as you work.
**2** Rulers for drawing up guidelines.
**3** Rubbers for removing pencil lines and some inks.
**4** Typewriter correction fluid for masking mistakes on items that are to be printed.
**5** Razor blade in holder; use this with care to correct special bits of lettering when you have made a mistake.

**6** Pencil sharpeners
**7** Sanding block for keeping pencils at a good point.
**8** Compasses; you will need a good pair of compasses if you incorporate circles into any of your designs.
**9** Proportional dividers; if you are doing lots of pieces of very precise calligraphy these will save you quite a lot of time when you are drawing up the individual lines and spacing them.

**10** Set square; it's important to use one of these to make sure that all your lines are parallel and at right angles to the edge of the paper.

**11** Scalpel for cutting paper, tape, clear film, and for erasing small mistakes.

**12** French curves; the curves on these will help you to draw smooth shapes if you are incorporating curves into your lettering.

**13** Protractor for marking off angles around circles or arcs.

**14** Clear film; this can be laid onto your paper and then cut away as a stencil.

**15** Templates; the regular shapes on these may be useful when you are planning or decorating your lettering.

©DIAGRAM

# Inks and colours

The ink you use for your lettering is just as important as your pen in achieving a good result, and there are many types of ink and colour available to the modern calligrapher. Ancient inks and colours were made of all kinds of materials such as soot and ground-up precious and semi-precious stones but modern manufacturing methods ensure that you can obtain a good, clear consistent colour in inks and paints. Inks are the colours used with pens; paints are used with brushes either for filling in lettering such as Versals or for outlining and decorating. Once again you don't need an enormous range of colours and types to begin with; buy some good black ink for early practice, and then slowly invest in more unusual colours and consistencies.

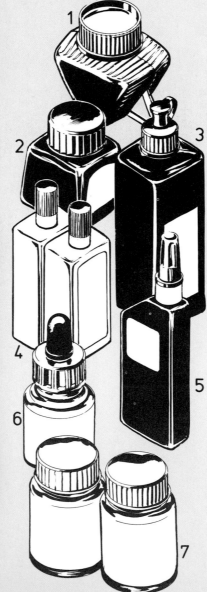

**1** Fountain pen ink is free-flowing, but usually not dense enough for good calligraphy. It is available in several colours and is quite passable for practising with.
**2** Indian ink is very opaque and dries to an almost waterproof finish; the high shellac content makes it unsuitable for fountain pens. Make sure that you clean all your pens and brushes thoroughly after using them with Indian ink.
**3** Calligraphy ink is a specially formulated black ink which can be used with all kinds of pens including fountain pens, and gives a good dense black finish.
**4** Coloured inks come in several different formulations, so check whether they are suitable for the kind of pen you want to use them with. Some are only suitable for use with a brush, as they are very pale. Others can be used with fountain pens and airbrushes.
**5** Technical pen ink is smooth and dense, and is available in a small range of colours as well as black.

**6** Drawing ink can be used with airbrushes, fountain pens or dip pens, and can also be diluted to any shade while still keeping a clear colour.

**7** Poster paints are bright paints with good covering power.

**8** Cake colours come in bright colours and may be opaque or translucent depending on their ingredients.

**9** Watercolours are translucent and can be obtained in cake or paste form.

**10** Powder paints are bright in colour, but need to be mixed with a medium such as gum or egg to bind them properly.

**11** Gouache is a designer's paint with good covering qualities.

**12** Acrylic paints are bright and versatile, and dry to an almost plastic sheen.

**13** Plaka paints are very bright and durable.

# inks and colours

### Metallic paints

Scribes of old used to illuminate their manuscripts with real gold, and many skilled scribes of today do the same. However, gilding is a very costly and time-consuming technique, and not many calligraphers have the chance to learn the skill properly. You can still add a sheen to your work with the use of metallic inks and paints; these are usually made of a clear ink or varnish with tiny particles of metal or plastic in them, which gives them a grainy texture, so they are not suitable for use in pens. They are available in gold, silver, bronze and sometimes in-between shades too. Try highlighting different areas of your letterforms and see the effects that you can obtain. It's also possible to buy sheets of gold and silver transfer paper; you do your lettering on the top, and the metallic pigment transfers to the paper underneath.

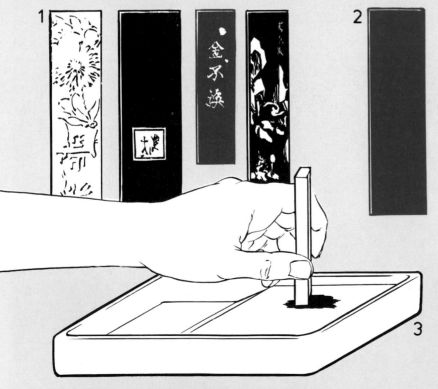

### Stick inks

Oriental calligraphy generally uses stick inks; these are shaped into all kinds of wonderful designs or stamped with calligraphic characters (**1**). These days it is possible to buy modern stick inks (**2**) in good art supply shops; they are available in several colours, although the traditional colours are black and red. The ink is ground by being held upright and rubbing it into a pool of water on a special palette (**3**); this is a job requiring patience, as it can't be hurried if you want to obtain a good ink with a regular colour.

## Palettes

Palettes of different shapes and sizes are very useful to the calligrapher; you can use them to mix up both inks and paints, for both pen and brush. You can mix two colours together to make a third, or you can water down a strong colour to make any number of variations on the basic shade. Use a different depression in the palette for each new colour, and clean them out thoroughly with paper tissues before the colour dries, otherwise they will harden onto the palette.

## Loading the brush

Brushes for oriental calligraphy or decoration need to be loaded with ink or paint very carefully so that you can achieve the desired effects. Use a shallow palette and roll the full length of the bristles in the paint or ink, rolling first to one side and then the other (**1**); the liquid should penetrate right to the tip and right up to the place where the bristles emerge from the shaft.

Then gently wipe the edges of the brush head against the side of the palette (**2**); remember that you are not trying to squeeze the ink out of the brush, but just to shape it well and make sure that there is no excess to drip over the work.

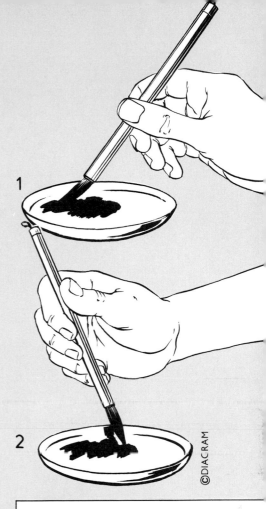

## Ink characteristics

You will find that each kind of ink has its own particular characteristics. Take a few pages in your notebook to try out any inks and suitable paints that you have at hand. Mix them with different amounts of water – do they keep a good tone, or do they go grainy? How well do they mix with other inks in the same range? Do they dry shiny or matt? Do the colours stay brilliant, or go duller? And – especially important with some of the coloured inks – do the colours stay permanent or do they fade after a few days in the light?

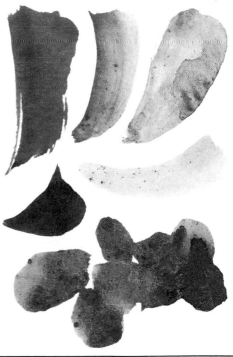

41

# Part Three

*S*mall *Lettres*

a b c d e f g h i k l m n o p q r ſ s
t u v w v x y z z zz & & &
a b c d e f g h i k l m n o p q , ſ s t
v u w x y z z & & & Q
a b c d e f g h i k l m n o p q r s t
v w u v x y z & & & et
*Lettres doubles, & liees*
ee ee ff ff gg gg ij ll m mn zr ſſ ſs tt w.

# BASICS OF LETTERING

*Capital Lrs.*

A A A A A B B B B B B C C C
D D D D E E E E F F F G G
G G H H H H J J J J I K K K
K L L & L M M M M N N N
O O O P P P P P P Q Q Q Q Q
R R R R R R R R S S S T T T
T T V V V V V V W W X X X
Y Y Y Y Z Z Z

©DIAGRAM

43

# Upper and lower case

Upper and lower case are the names given to the two different types of alphabet that we are familiar with; sometimes they are called capitals and small letters, and sometimes they are known and majuscules and minuscules. The names upper and lower case come from the days when type was set by hand; the capital letters were in the upper type tray, or case, and the small letters were in the lower one.

Lower case letters are easier to read in bulk, because their internal variation is greater and the ascenders and descenders (see p 48) give more immediate clues to the letterforms. Try for yourself writing out a long message in capitals and then reading it through; it is quite tiring on the eyes and concentration.

**Standard forms**
The illustrations on this page show the basic forms of the standard upper and lower case alphabets. These are based on the classic Roman alphabets (see p 72).

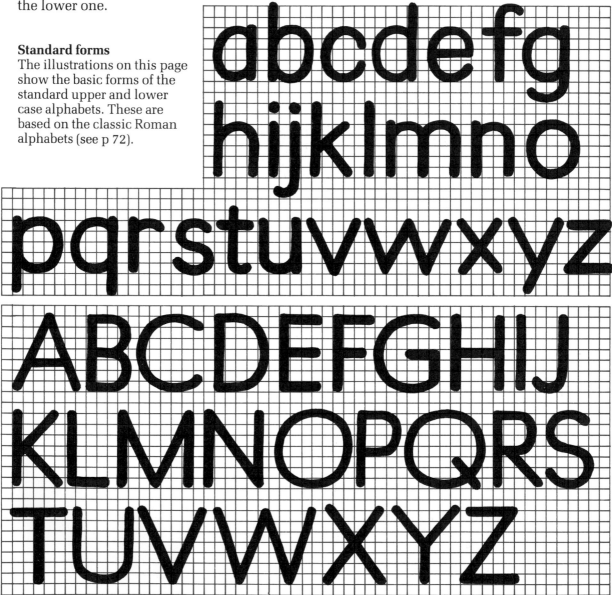

## Variations

There are, of course, variations on the standard forms of these letters. The examples here show a few of them.

## Experimenting

The example here shows many variations on a G. Experiment in your notebook with as many ways as you can think of for drawing each letter.

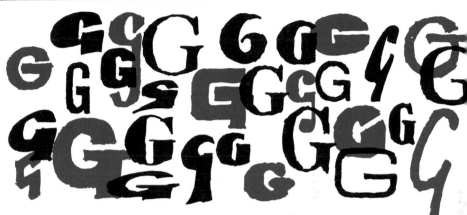

## Fundamentals

What is it that makes a G a G? Or an A an A (or an a!)? What are the essential characteristics of each letter of the alphabet? Take a few pages in your notebook and try to reduce each letter to its fundamentals, so that you can still tell which basic letter it is. The example here shows an upper case alphabet that has been subjected to this treatment.

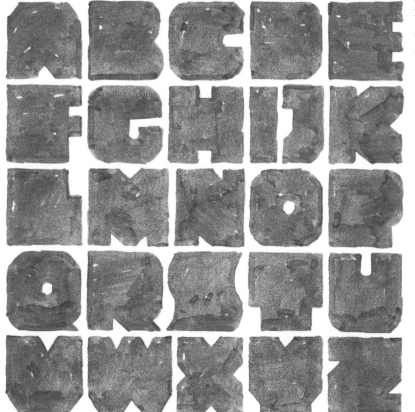

©DIAGRAM

# Letter proportions

The internal proportions of letters, and their relationship to one another, determine some of the main characteristics of particular styles of lettering. The basic proportions of upper and lower case alphabets are fairly consistent from one letterform to another, but there will be subtle variations that will be important if you are wanting to reproduce a specific alphabet accurately. Make yourself familiar with the standard proportions of the letterforms, and then you will be able to spot any divergences quickly, for instance, if the lower case g is noticeably wider than the b, or if the upper case I has extra-wide cross-strokes.

**Basic shapes**
These diagrams show the basic shapes occupied by standard upper case and lower case alphabets. Notice that although there is more variation in the shapes of lower case letters, most of them occupy a similar amount of space for the main part of the letter.

abcdefg
hijklmno
pqrstuvwxyz
ABCDEFGHIJ
KLMNOPQRS
TUVWXYZ

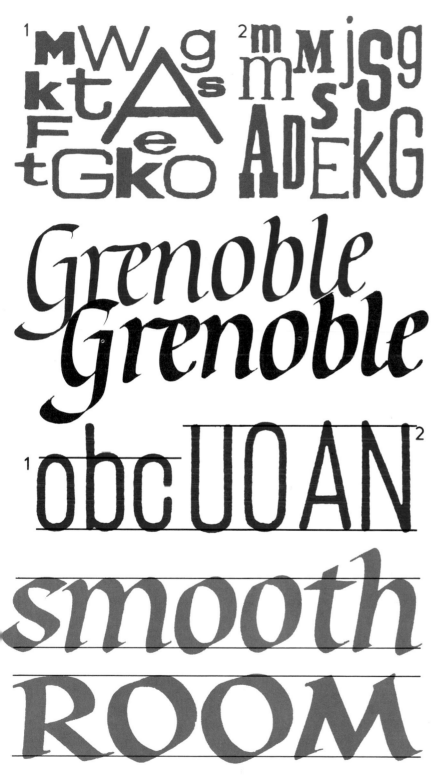

### Narrow and wide

When letterforms are particularly wide in relation to their height, they are called expanded forms. When they are especially narrow, they are called condensed. Shown here are various expanded (**1**) and condensed (**2**) forms of standard letters; try your own versions out in your sketchbook.

### Internal proportions

The internal proportions of letters are determined mainly by the ratio of the width of the pen to the height of the letter. If the number of pen widths in the height is large, for instance 9 or 10, the letter weight will appear quite fine; if the number of pen widths in the height is small, for instance 5 or 6, the letter weight will appear bolder.

### Visual spacing

The proportions of letterforms are slightly distorted by our eyes; for instance, because curved letters have larger counters than straight letters (see p 49) we 'see' more space around them than there really is. This is compensated for in calligraphy by making sure that curves go slightly over the ruled guidelines so that part of the letter is slightly larger than it would be otherwise (**1**). The same principle applies to letters with points, such as A and N (**2**). The examples (*left*) show how the curves of the letters are formed to look visually correct.

# Parts of a letter

It is important to know the different parts of the letters of the alphabet so that you can look out for their particular characteristics when working on a particular letterform. There are many precise and detailed parts of a letter, used by type designers and specialist letterers, but it is not necessary to know all of them; the main parts are illustrated on these pages. Many of these names will be referred to later in the book in relation to particular alphabets or styles of lettering.

**Height**
Letter height is divided into three heights. The x height (**1**) is the measurement of the main body of the lower case letters, for instance from the top to the bottom of a lower case o. The bottom of the x height is called the baseline. The ascender height (**2**) is from the baseline to the top of the ascenders of the lower case letters, for instance, k. Capital height (**3**) is from the baseline to the top of the capital letter and usually one or two pen widths lower than the ascender height.

**Ascenders and descenders**
Ascenders are the strokes of lower case letters that go above the x height. Letters with ascenders are b,d,f,h,k,l, and t; in many alphabets the ascender of the t is not as high as the others. Descenders are the strokes that go below the x height; letters with descenders are g,j,p,q, and y, and sometimes f.

**Cross-strokes**
Some letters have an intrinsic horizontal (or nearly horizontal) cross-stroke; these are e,f,t in the lower case, and A,E,F,H,I,J and T in the upper case. In some very plain forms the upper case I and J do not have a cross-stroke.

Roskilder

Roskilder

bdfhklt

gjpqyf

AEFHIJT

eft

## Serifs

Serifs are marks made on the ends of main lettering strokes.

They can take many forms, from a slight swelling to an enormous slab. Serifs are one of the main characteristics that differentiate letterforms and eras, so learn to distinguish and reproduce the varying kinds.

**1** Bracketed serif
**2** Slab serif
**3** Hairline serif
**4** Wedged serif
**5** Swelled stroke
**6** Bracketed slab serif
**7** Diamond-shaped serif
**8** Cross-stroke
**9** Clubbed serif

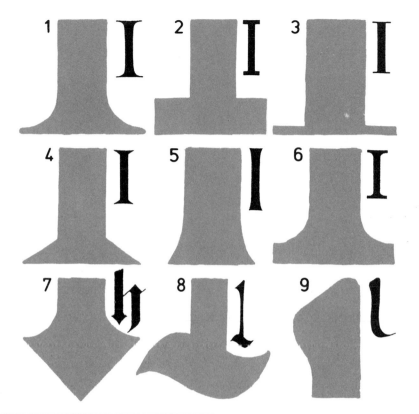

## Counters

The counters are the spaces within and around a letter; when two letters are next to one another, the counter can also refer to the shaped space between them. In these drawings, the counters are marked by a shaded area.

## Tails and swashes

The two capital letters that have tails are Q and R; other letters may be decorated at times by swashes – tails that are added for aesthetic effect.

# Letterspacing

The amount of space between individual letters and between words is vitally important in good lettering. When you are beginning you will probably tend to allow the same amount of space between any combination of letters, but in fact this will look wrong visually. The counters of the letters (see p 49) determine the amount of space between any two letters; if the counters are large and open, then this already provides some of the space and the interletter spacing does not need to be so large. The same is true of interword spacing. To begin with you will probably space your letters too widely; this doesn't matter, as it gives you a chance to form the letters accurately and without cramping, but as your eye becomes more sure the spaces will decrease.

### Even and uneven
It would seem logical to allow an even amount of space between each pair of letters in a word. This works fine when the letters are single upright strokes, or when they are within rectangular shapes (**1**). However, when curved letters or ones with large counters are introduced, this spacing becomes too large; the o and the capital A in the examples shown seem to be separated from the other letters in the words (**2**).

### Adjusting counters
The lines that need most space between them are two verticals (**1**), for instance an i and an l. A medium amount of space is needed between a vertical letter and a curved letter, for instance b followed by l or o followed by i (**2**). The smallest amount of space is needed between two curved letters, (**3**), for example, o and c or b and o.
The examples (*left*) show the same word written with even spacing, and then with irregular spacing that takes into account the different relationships of the letters.

## Spacing ligatures

When you are writing alphabets that have ligatures, for instance, some versions of rounded and Italic hands, you will find it easier to letterspace the words in a more pleasing way if you break the ligatures.

**1** With ligatures
**2** Without ligatures

1 *exhibit*

2 *exhibit*

## Visual spacing

Some letters with large counters can be virtually butted up, as their very different shapes make it impossible to confuse them. For instance, an upper case A and T next to each other look too far apart when their counters are entirely separated (**1**); they can be moved very close together without looking strange (**2**). Also, the larger the letterform the smaller the relative letterspacing can be; the large size of the forms makes them easier to recognise without them needing to stand in their own area of white space (**3**).

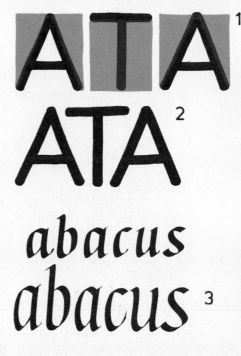

ATA 1

ATA 2

abacus

abacus 3

## Wordspacing

The spacing between words follows much the same rules as spacing within words when you are doing showcase pieces of lettering consisting of only a few well-spaced words. If you are doing a long passage of text in a rather smaller size you will not want to fiddle about balancing each and every word with its predecessor. A good general rule is to leave the space of a lower case n between words in lower case, and the space of an upper case O when writing capitals. However, since this can make the piece of writing look too spaced out depending on the alphabet you are using, you will automatically make adjustments to correct this as you become more experienced.

*thenquicknbrown*

*foxnjumpsnover*

*thenlazyndog*

WEEP THEIR BURDEN

THERE IS ONLY
THE TRAVELING

DENEN ES VON DEN GÖTTERN

# Slant and stress

Two characteristics that are very important in lettering are slant and stress. Once you have learned to identify the slant and stress of a particular letterform, it will be much easier to imitate it. Both characteristics are constant within a well-designed letterform; for instance, if one upright stroke is perpendicular, so should the others be. If one letter is written with the pen at an angle of 40°, then all the letters in that face should be written with the pen at the same angle.

**Word slant**
In a consistent letterform, there will be a rhythm within the letters when they are formed into words. All of the main uprights, ascenders, descenders, etc, will be at the same angle. This is one of the features to pay very careful attention to, as consistency in slant is one of the main characteristics of good lettering.

**Slant**
Slant is to do with the angle of the upright strokes of the letterform. The best way to check it is to look at several of the clearest upright strokes, for instance the ascenders of b, d and h. Are they perpendicular, or angled to the right or left? Check the capitals too, for instance the H and I.

**Weight**
Weight is the quality of the main lines in the letterform – whether they are thick or thin in relation to the height. If the lines are thin (**1**) the face can be described as fine or light; if they are in between (**2**) then the weight is medium, and if they are thick (**3**) then the face is bold or heavy.

**Ratios**
Most faces do not have strokes that are a consistent thickness or weight all the way through. Generally some lines are thicker than others – this is usually particularly noticeable on the capital A and V. The difference may be very slight (**1**), definite (**2**) or very marked (**3**).

## Stress

Stress is the internal angle of the letterform, and refers to the angle at which the tool making the letters is held. Stress is not necessarily related to slant. To discover the different stresses that can occur in letterforms, tie two pencils together and draw a letter U as shown.

**1** Upright or vertical stress
**2** Angled anticlockwise at 30°
**3** Angled anticlockwise at 60°
**4** Horizontal stress
**5** Angled clockwise at 45°

## Stressed letterforms

The letters shown here all show a particular internal stress.

**1** Letters with vertical stress
**2** Letters with anticlockwise stress
**3** Letters with horizontal stress

## Angularity

The angularity of a particular letterform is also useful to note when you are trying to imitate it. To spot the angularity, look at a rounded letter such as the lower case o; this will tell you whether the letterform is rounded, squared, angular, chiselled, squat, etc.

©DIAGRAM

53

# Linespacing

Once you have sorted out the amount of space to leave between letters and words, you will need to practise gauging the correct amount of space between lines. As with the wordspacing, there are basic principles of good design which you will need to understand first; once you have mastered these, you will be able to experiment with your own variations on the basic principles.

**Principles of linespacing**
In general, the minimum amount of space that you should leave between two lines of lettering is the amount needed for the descenders of the top line plus the ascenders of the bottom line (**1**). If you don't leave enough space the ascenders and descenders will become confused (**2**). You can, however, leave more space in between the lines (**3** and **4**) to introduce a lighter feel to your calligraphy.

angling is a popular
1 sport for children

angling is a popular
2 sport for children

angling is a popular
3 sport for children

angling is a popular
4 sport for children

**Capitals**
In spacing capitals the main consideration should be the proportions surrounding them. A familiar message placed only half a letter height apart has a quiet and dignified tone (**1**) but, with the space of a capital letter between the lines, the letters shout their message (**2**).

WE ARE
CLOSED
1

WE ARE
CLOSED
2

Above all things,
take care of your head and
keep it moderately warm,
and see that you never wash:
have yourself rubbed down
but do not wash

## Bending the rules

The composition of a page is very important so the space around a piece of lettering needs planning before linespacing is decided upon. The example (*left*) shows a well-balanced piece of writing. There are no hard and fast rules.

## Different ratios

Different letterforms have different ratios of x height to ascender height and so will need different amounts of spacing between the lines. Extreme examples of this are Carolingian hands (**1**), which as well as having tall ascenders are written with a great deal of interline spacing, and some of the Gothic hands (**2**) which have extremely short ascenders and descenders, so lines are placed much closer together.

Short messages, with no descenders in the top line, can be placed close together and, for special effect, the descenders from one line can overlap the ascenders of another.

**1** is essec secersit u

uitatenazareth u

ramam.infinib: z

zur quoddicaim

ulon etterra nepr

alilene. Gentium

em uidicmagnam

moras luxora

pitilis praedicare

opinquauitenim

ixtamarezalilene

©DIAGRAM

**2** a quick brown
fox jumps over
the lazy dog

# Alignment

Once you have chosen the area that you want to use as a boundary for your lettering, you need to select the alignment. This refers to whether the left-hand or right-hand edges of your lettering line up – or whether they both do, or neither. The alignment can be used sometimes to express formality or informality; for instance, it might be appropriate to do a citation for valour in a justified block, and an informal invitation to an open house in a seemingly casual asymmetric alignment.

 OMINA MEA
Sancta Maria, me in tuam bene-
dictam fidem, ac singulârem cuſto-
diam & in ſinum miſericordiæ tuæ, hódie, &
quotidie. & in hora éxitus mei. & animam
meam, & corpus meum tibi comméndo: óm-
nem ſpem meam & conſolatiónem meam, om-
nes anguſtias & miſérias meas, vitam & finem
vitæ meæ tibi committo; ut per tuam ſanctiſſi-
mam interceſſiónem, & per tua merita. ómnia
mea dirigántur, & diſponántur ópera ſecún-
dùm tuam, tuique Filij voluntátem. Amen

**Types of alignment**
The five basic styles of lettering alignment are illustrated here.
**1** Justified; both the left-hand and the right-hand edges line up with each other.
**2** Centred; the lines are uneven in length, but symmetrical down the centre.
**3** Ranged left, ragged right
**4** Ranged right, ragged left
**5** Asymmetric

**Line fitting**
The length of your longest line may influence the nib size used. The example (*below*) shows lettering in the same size but condensed to fit the space. You could, however, introduce different nib sizes to different sections of a complex piece.

*fitting a line to a predetermined space*

*fitting a line to a predetermined space*

*fitting a line to a predetermined space*

### Centred lettering

Centred lettering requires some careful planning, as each half of each line has to be the same length. Draw a rough version out first to check how long each line is; measure the half-way point on each line, then use that to centre the lines above each other.

### Ranged left

Lettering that is ranged left is the easiest kind for western people to do. As we write from left to right, we simply begin at the left-hand margin and fill out each line with as many whole words as possible.

### Ranged right

Lettering that is ranged right is a little more difficult; as each line has to finish at the same margin, you might find that you run out of space or are left with a gap. Letter out a rough version first to check the fit.

### Asymmetric

Asymmetric layouts look deceptively easy, but it is quite an art finding the pleasing balances of lettering and space around the words. Experiment by arranging the same elements in as many different ways as possible on a page.

### Spacing headlines

Headings can be varied more than text lettering. The example (*below*) shows the same size letters but using different pen widths. The drawn capitals (*bottom*) show letters getting bigger but filling the same width. The first is too spaced and the last too tight.

57

# Page layout

Page layout is an art in itself; the look of the final page can be just as important as the quality of the actual lettering. The aim is to achieve a page that looks well balanced; not too crowded, not with all the elements on one side, and not with too much white space around the work. Use lots of pages in your sketchbook to experiment with some of the ideas on these pages, and to draw up as many different ways you can think of for arranging the different elements on a page. Some of the arrangements will be pleasing to the eye, others less so. Be bold and inventive once you have grasped the basic principles of page layout; you might happen across some unusual layouts that will look stunning when they are worked up into finished calligraphy.

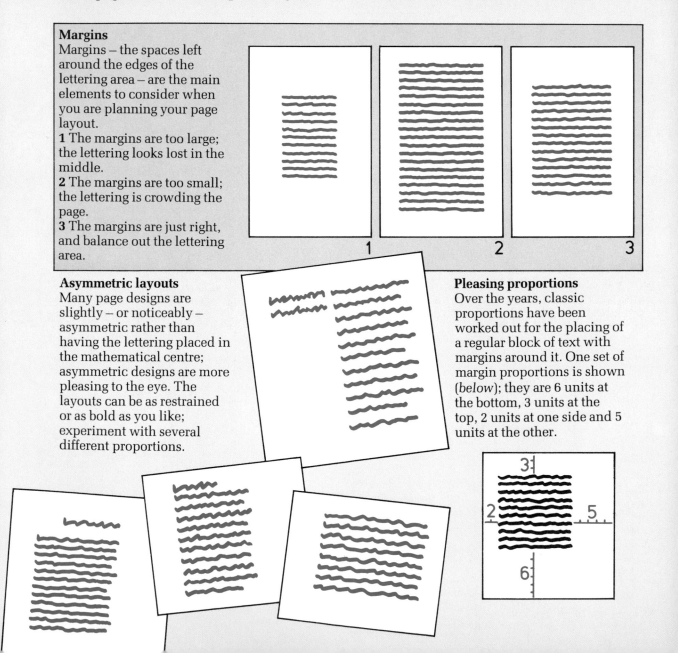

### Margins

Margins – the spaces left around the edges of the lettering area – are the main elements to consider when you are planning your page layout.

**1** The margins are too large; the lettering looks lost in the middle.

**2** The margins are too small; the lettering is crowding the page.

**3** The margins are just right, and balance out the lettering area.

### Asymmetric layouts

Many page designs are slightly – or noticeably – asymmetric rather than having the lettering placed in the mathematical centre; asymmetric designs are more pleasing to the eye. The layouts can be as restrained or as bold as you like; experiment with several different proportions.

### Pleasing proportions

Over the years, classic proportions have been worked out for the placing of a regular block of text with margins around it. One set of margin proportions is shown (*below*); they are 6 units at the bottom, 3 units at the top, 2 units at one side and 5 units at the other.

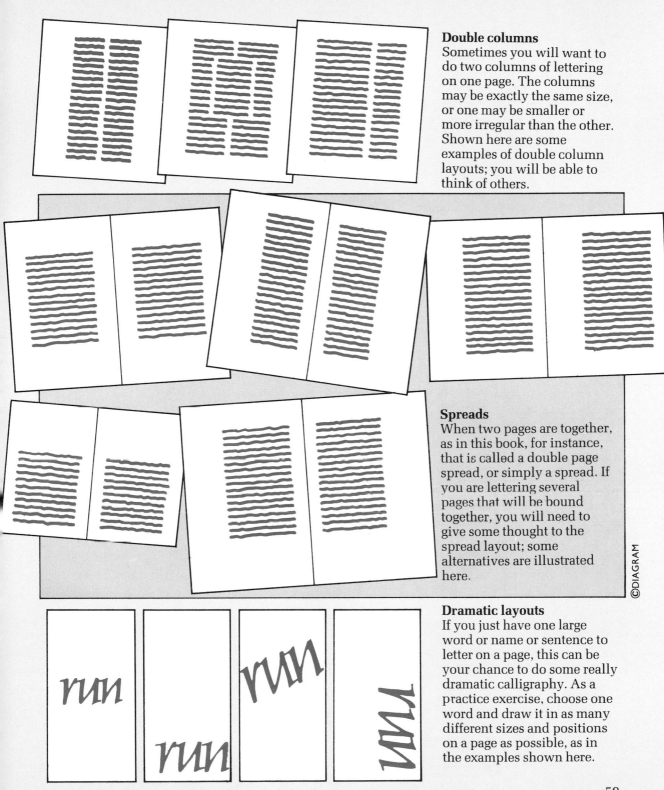

## Double columns

Sometimes you will want to do two columns of lettering on one page. The columns may be exactly the same size, or one may be smaller or more irregular than the other. Shown here are some examples of double column layouts; you will be able to think of others.

## Spreads

When two pages are together, as in this book, for instance, that is called a double page spread, or simply a spread. If you are lettering several pages that will be bound together, you will need to give some thought to the spread layout; some alternatives are illustrated here.

## Dramatic layouts

If you just have one large word or name or sentence to letter on a page, this can be your chance to do some really dramatic calligraphy. As a practice exercise, choose one word and draw it in as many different sizes and positions on a page as possible, as in the examples shown here.

©DIAGRAM

# Unusual layout

Once you have mastered the art of lettering within straight lines, you will be able to fit your lettering into more exotic shapes. The shapes can be chosen for their aesthetic lines, for example, a circle or a perfect square, or they can reflect something of the content of the lettering inside; for instance, an anniversary letter could be enclosed within a number, a love poem could be written out in a heart shape, or a Christmas newsletter could be fitted into the outline of a star or a Christmas tree.

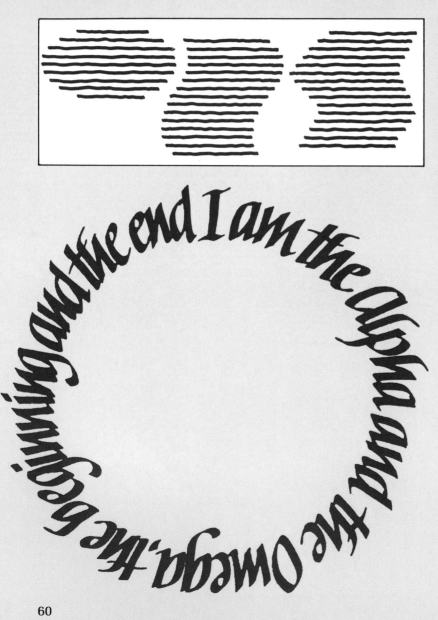

### Choosing the shape
Choose a shape that is not too complicated, so that it won't be too hard to make the lines work inside it. Draw the outline out in rough first of all so that you can plan how widely to space the lines and exactly which words you will fit on each line.

### Circles
Lettering round a circle gives a very beautiful effect, although too much of it is difficult to read! If you just want one circle of lettering you will need to plan the letterspacing and wordspacing very carefully. If you are working in a spiral it is possible to be much more immediate; you can begin at the centre or on the circumference – but make sure that you have enough room left to finish if you work from the outside in.

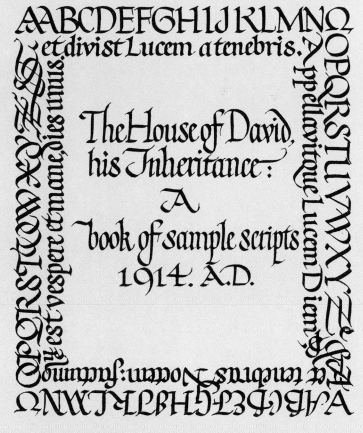

## Squares and rectangles

Squares and rectangles are very satisfying shapes to work in; they give a formal outline to hold the lettering together, yet allow a great deal of freedom within. You can either work around the straight lines of the shape, or do your lettering asymmetrically within.

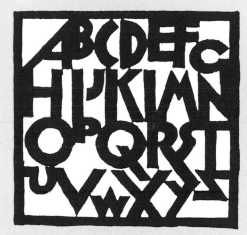

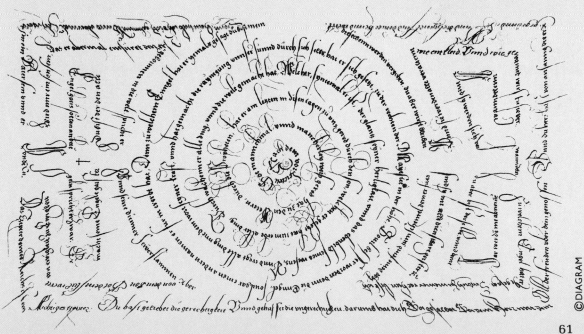

61

# unusual layout

**Asymmetric shapes**
Some shapes simply can't be classified in formal terms, and these unique shapes can often be the basis for striking calligraphy, as some of these examples show. However, you can keep the outlines simple so they don't detract from the lettering, as the two excellent examples (*far right*) by Ieuan Rees illustrate.

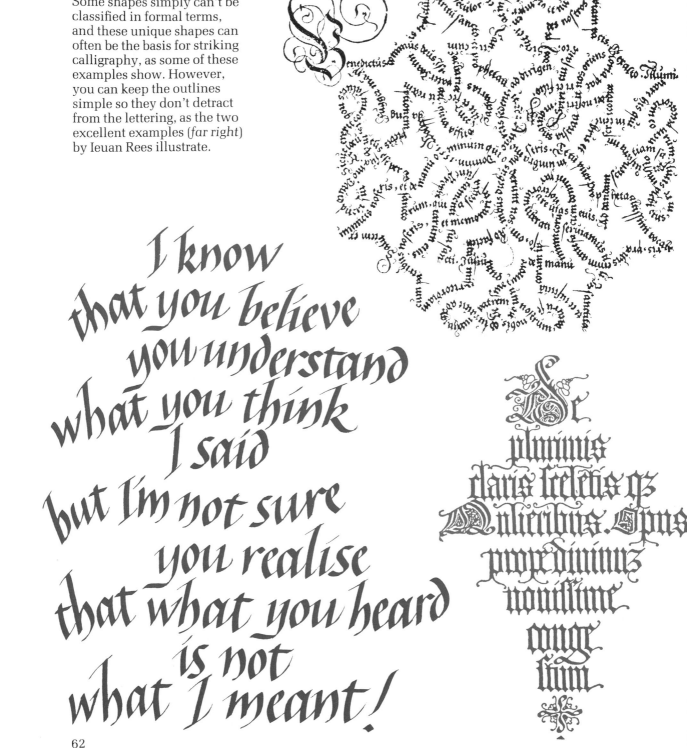

I know
that you believe
you understand
what you think
I said
but I'm not sure
you realise
that what you heard
is not
what I meant!

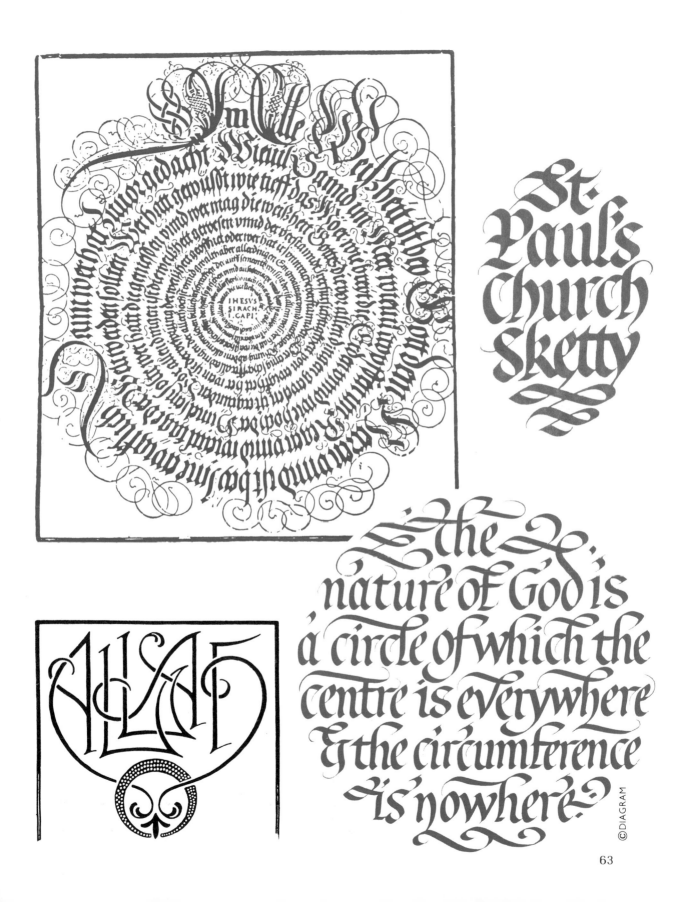

St. Paul's Church Sketty

The nature of God is a circle of which the centre is everywhere & the circumference is nowhere.

© DIAGRAM

63

# Initial letters

Initial letters are a dramatic way of livening up a plain piece of lettering, or of providing the opportunity for an extra-fancy piece of penmanship. Very elaborate initial letters (see p 164 for ways of decorating them) should be used sparingly; their best use is as a single decoration at the start of a piece of work. Less elaborate large letters can be used for the beginning of names, or at the start of a new paragraph – or to begin each line if you have a list.

### Drop capitals

Drop capitals are outsize capital letters that are 'dropped' into the text below, so that they take up space that would normally be filled with lettering. Simple drop capitals may take up only one extra line; more elaborate forms may eat into many lines, or even a whole page.

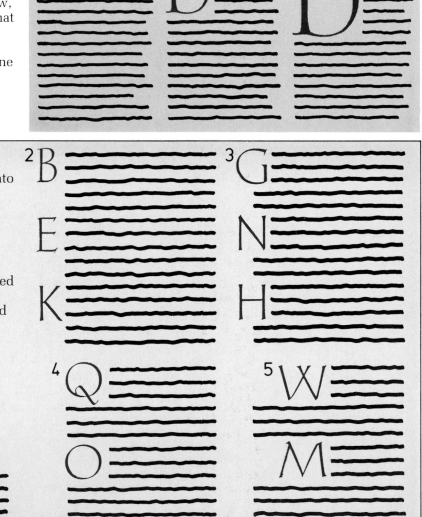

### Vertical alignment

There are several ways of introducing initial letters into the rest of the text.

**1** The letter takes a line to itself; this form is not often used these days.

**2** The letter is outside the lettering area.

**3** The letter is partly indented into the lettering area.

**4** The letter is fully indented to align with the rest of the lettering.

**5** The indent is even more marked.

## Horizontal alignment

Instead of a drop capital, the initial letter may be aligned with the bottom of the first line of lettering, or it may be partly dropped.

**1** Drop capital
**2** Initial letter aligned with first line of lettering
**3** Partially dropped capital

## Visual spacing

When the initial letter has straight sides, such as N or H, there is no difficulty over where to start the lines of lettering. However, when there is a large counter, such as with V, R, L or K, the lettering looks better if it is moved in to fill up the counter. This is also true to a lesser extent of B, O, F and similar letters.

*Knowledge is the treasure of the Minde but Discretion is the Keye without which it lyes dead in the dulnesse of a fruitlesse rest The practicque part of Wisdome is the best There is a flowing noblenesse some are graced with farre transcending the motions of a timed studie.*

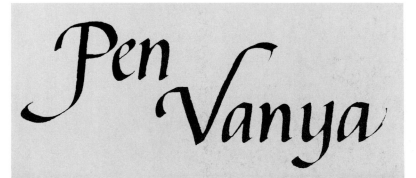

## Swashes

Swashes can look very effective when used on initial letters for single words, names, etc. Make sure that you have enough room to do the swashes unhampered by later lettering.

# Unusual letterfitting and spacing

Once you have mastered the basic principles of good letterspacing and wordspacing, you will be able to experiment with more bold and unconventional types of spacing – aligning the letters unevenly, or vertically; tucking smaller letters into larger ones; lettering at angles, etc. These are by no means all new tricks; ancient manuscripts of many traditions make use of some of these variations for visual effect or to fit in long words. Avoid using vertical arrangements of letters except very sparingly; they are much harder to read than when the letters – or words – are written horizontally. As a practice exercise, choose one word, perhaps your name, and see how many different ways you can discover for altering its letterspacing.

**Letterfitting** (*right*)
In many ancient manuscripts small letters were fitted inside or alongside larger ones, sometimes to fill up the large empty counters of, for instance, an L or a C. Another way of squeezing letters into a smaller space is to loop them together.

**Wordspacing**
A great deal of visual movement can be introduced into your lettering with unusual wordspacing or layout of words. Some examples are shown (*below*); use your sketchbook to try out others.

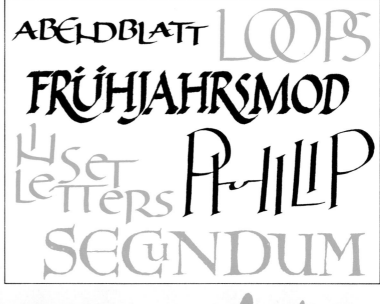

**Angles** (*right*)
Most lettering is horizontal, so introducing a new angle can provide immediate visual interest. Try some lettering vertically, slanted on the page, going round a corner or round the edge of a circle.

I thought the last of all my cares...

whosoever has taught me ONE LETTER has made me his slave

**Varying sizes**
You don't always have to stick to the same size of lettering within the same piece of calligraphy. These examples show how variation can be introduced very simply by using several sizes of lettering; the arrangement (*left*) is informal and the lines of varied lengths whereas the lettering (*below*) has been expanded so that each line fits a given width.

HE WHO THE SWORD OF HEAVEN WILL BEAR

©DIAGRAM

67

# Part Four

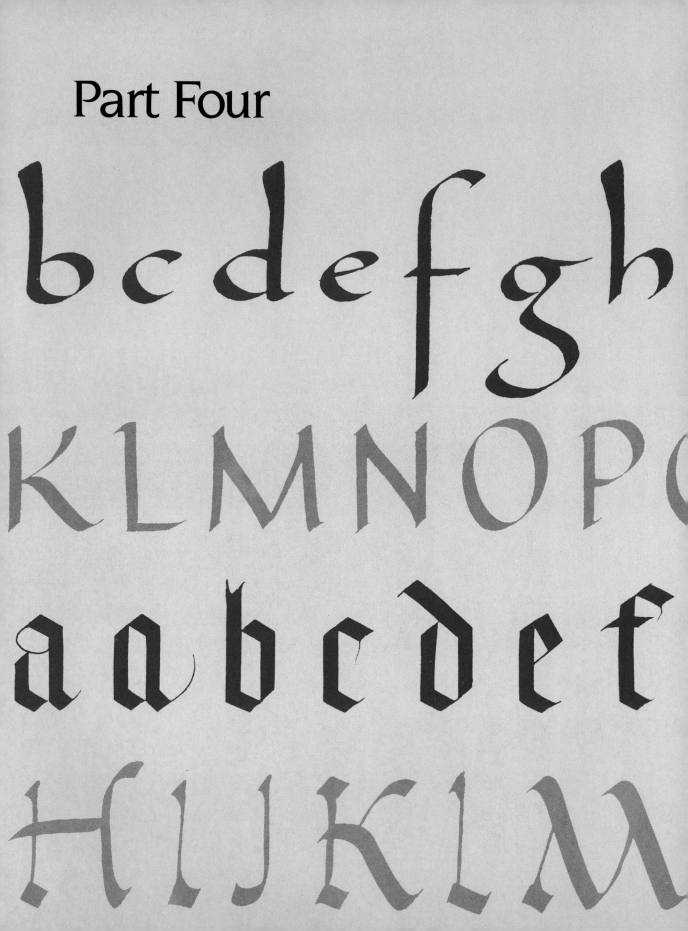

# ALPHABETS

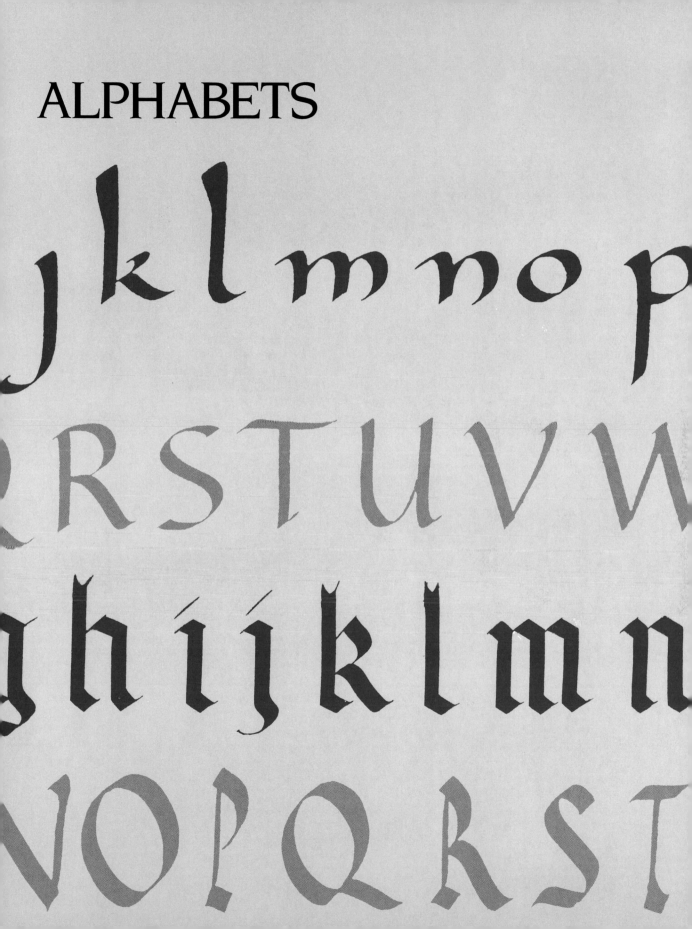

# Roman

Our modern western capital alphabet has its origins in the monumental Roman style of the first century AD. Twenty-three of the letters of our alphabet take their basic form from the Roman Empire models, with U, J and W being added in mediaeval times. There are many examples of this type of lettering that can still be seen on monuments, tombs and inscriptions throughout Italy and other parts of Europe, and the style has been held up as the letterform design that is nearest to 'perfection', in the relationships of the curves and the systematic design of the strokes and serifs. The geometric principles of the square and the circle are very evident in the purest examples of Roman lettering, and also the style has been influenced by the tools used to form it – mainly brushes and chisels. However, the real beauty of some of the finest examples transcends simple geometric equations.

The Roman letterers used sound mathematical principles together with the powerful influence of optical illusion and the best example of their work, Trajan's Column in Rome, shows how visual rather than purely mathematical spacing is more satisfying. During the Italian Renaissance Roman majuscules were used with Carolingian minuscules, and now in the 20th century we still see this Column as the starting point for our own studies of the basic principles of good lettering and calligraphy.

### Developing forms
**1** A Trajan inscription carved in 114 AD, which stands at the heart of Ancient Rome.
**2** The square-cut reed pen imitated the stone-cut Roman letterform.
**3** A typeface such as Bembo shows all the characteristics of Roman forms.

### Tools
The original tools used for many Roman inscriptions were the hammer and chisel, but the same forms could also be made with a brush. You can try Roman lettering with a fine brush to work the outlines, then filling in with a broader brush, or you can do the same with a pen; alternatively, you can experiment with broad-nibbed pens or brushes and try making each stroke with one movement.

### Instructions
Roman lettering is worked with the pen at an angle of 30° from the horizontal, or 60° from the vertical (**1**). The stress of the letterform is diagonal (**2**); the exact angle of the stress will depend on the variety of Roman lettering that you are doing.

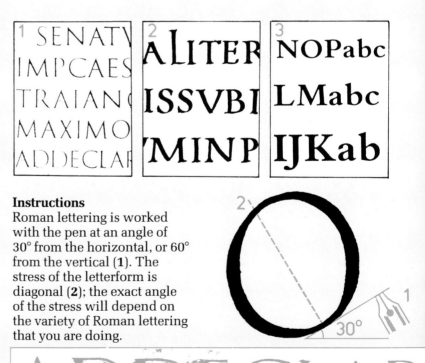

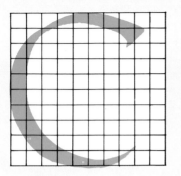

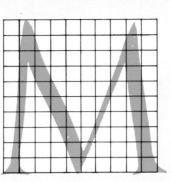

## Proportions

The proportions shown here will give you a good basis to practise on. Use guidelines for the whole letterform the equivalent of 7 times the thickest point of the stroke; the thickness of the vertical stroke will be one-tenth of the height because of the pen angle of 30°.

## Strokes

The vertical and diagonal strokes are written first from top to bottom, then the cross-strokes, and finally the serifs which, on vertical strokes, extend on both sides. To achieve these you have to turn the pen at right angles to the stroke.

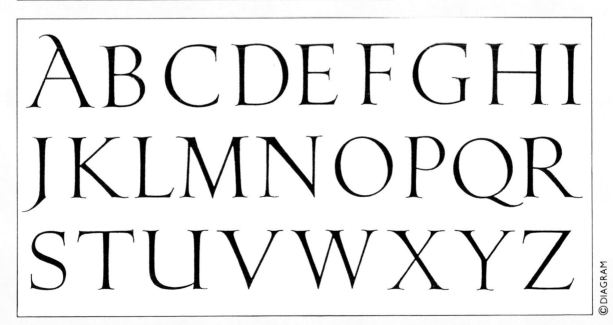

# roman

The classic Roman alphabet is one of the most carefully constructed letterforms that we know. It is well proportioned and very beautiful, and it is worth knowing just how each letter can be constructed for maximum grace and precision. These pages show the shapes and constructions of the basic forms in the capital alphabet.

**Grids**
Each of the Roman capitals can be constructed within a rigid squared grid. The widest letters are the M and W, closely followed by the round letters C,D,G,O and Q. Next come A,H,N,T,U,V,X,Y and Z. The letters B,E,F,K,L, P,R and S are somewhat narrower, and the narrowest of all are I and J.

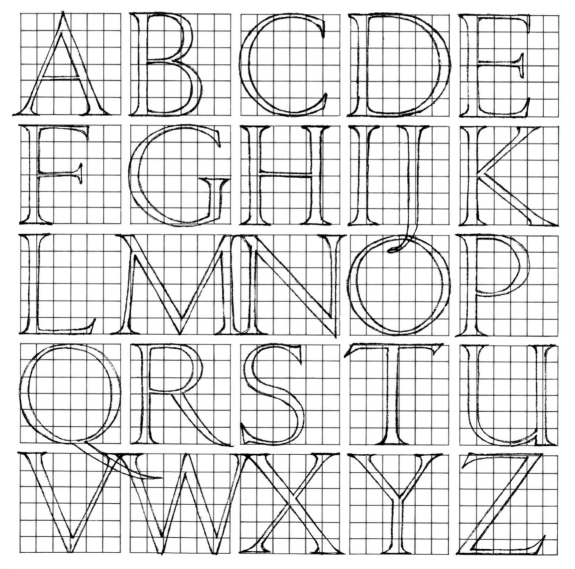

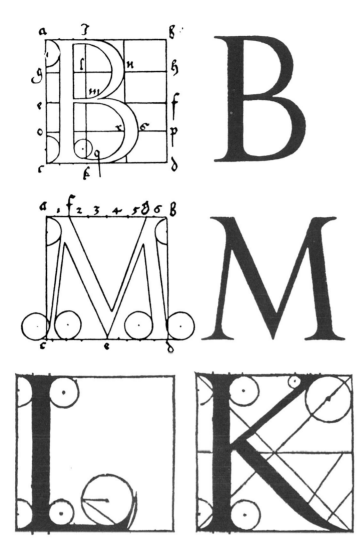

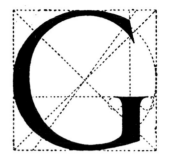

## Construction
The geometrical construction of the Roman capitals can be seen in these examples from later writing manuals. Notice the way that all of the serifs and internal curves are based on arcs of a circle.

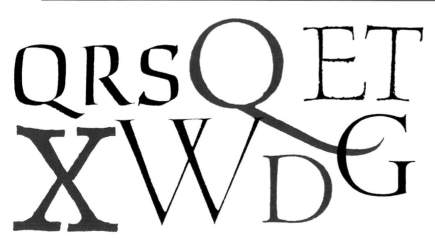

## Variations
Numerous variations have been developed of Roman capitals, both in Roman times and since; the changes were often related to the tool being used to form the letters – for instance whether it was a reed pen, a steel nib, or a stonecarver's chisel. The examples here show some of the many ancient and modern alternatives to the standard letterforms.

# roman

The Foundational Hand was developed by Edward Johnston from a 10th-century English script which was standard for scribes. The vertical strokes on this majuscule alphabet are precisely perpendicular. There is little difference in weight between the vertical and diagonal strokes as the pen is held at an angle of less than 45°, except in the case of the vertical strokes of the N where the pen angle is steepened to lighten their weight. The serifs are formed by turning the pen.

ABCDEFG
HIJKLMN
OPQRSTU
VWXYZ&
1234567890

PARIS BRUGES

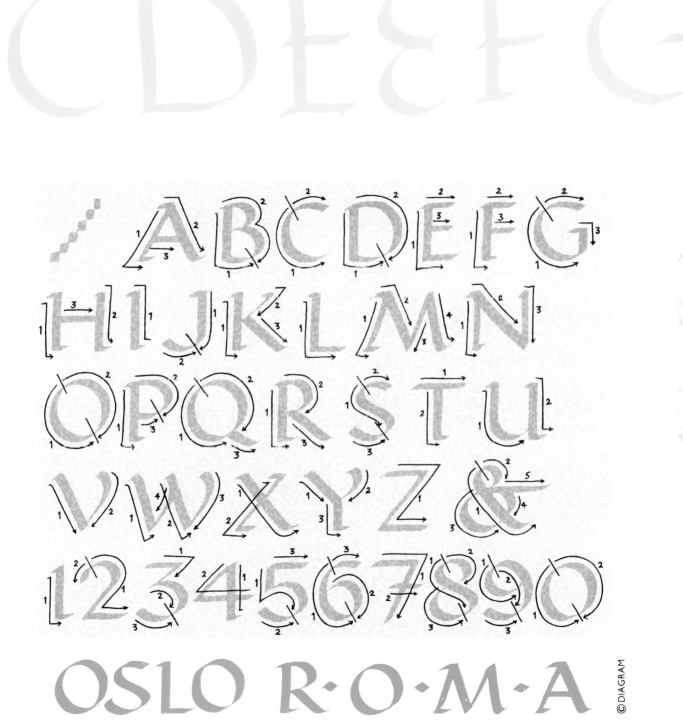

OSLO R·O·M·A

© DIAGRAM

75

# roman

The Foundational minuscule alphabet developed by Edward Johnston also has perpendicular upright strokes. The writing should never be allowed to slope backwards. The pen angle is 30° except for the V and W where it steepens to 45°.

The example (*below*) is from Johnston's *Book of Sample Scripts* which was originally written on vellum in black and red letters in a variety of scripts.

they, and all the men
ale of Elah, fighting
And David rose up
nd left the sheep
, and went, as Jesse
; and he came to the
the host which was
shouted for the
the Philistines put
y against army.

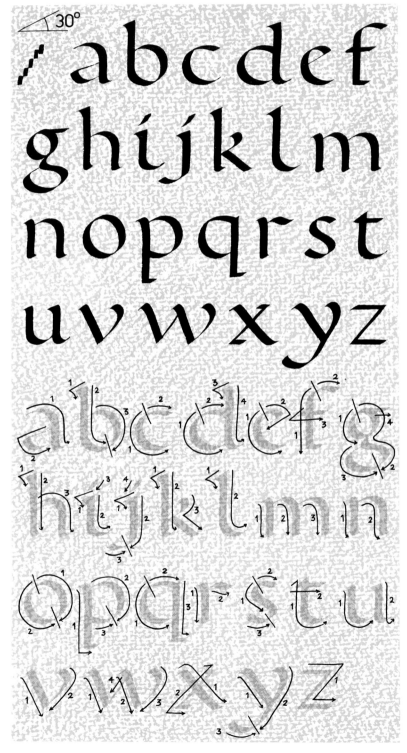

The capital alphabet (*below*) shows the basic construction of the letters without serifs. The characteristic is the combination of thick and thin strokes. Tie two pencils together so that the construction of the strokes is understood. The skeleton letters show the construction of the serifs.

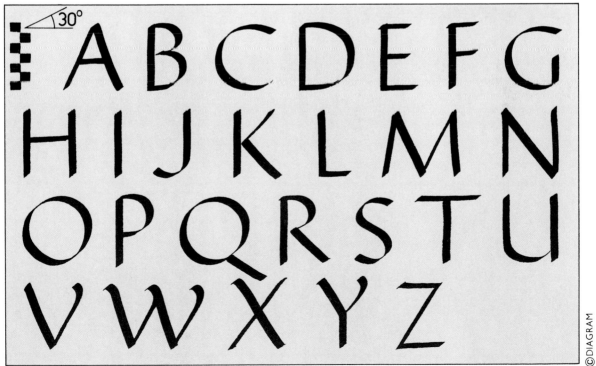

# *roman*

This alphabet, upper and lower case, is a modern interpretation of the Roman letter. The stress is diagonal, but the letterforms are fairly condensed with a squared off, slightly chiselled feel.

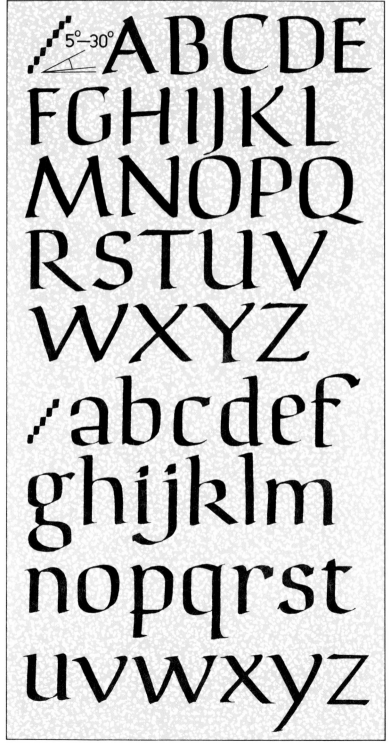

**Square shapes**
Most of the curves in this alphabet are squared off; they could almost fill the sides of a rectangle. Compare them with the more rounded shape of the classic Roman.
**1** Roman capital C
**2** Squared off capital C
**3** Roman lower case p
**4** Squared off lower case p

This elegant Roman capital alphabet
could be worked in a pen or brush as
some of the strokes are very fine.

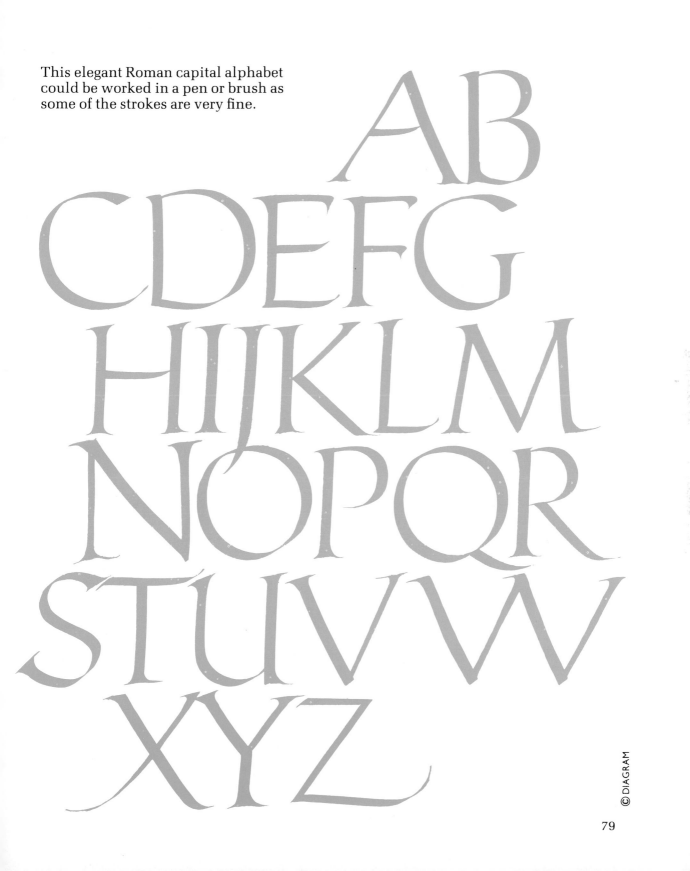

# Rustica

Rustica, or the Rustic alphabet, was originally painted with reed pens or large brushes. It was a bastardised form of Roman lettering; people became sloppy about the precise shapes and characteristics, and this rather elongated version with marked cross-strokes emerged. Lettering of this kind can still be seen on the walls of Pompeii.

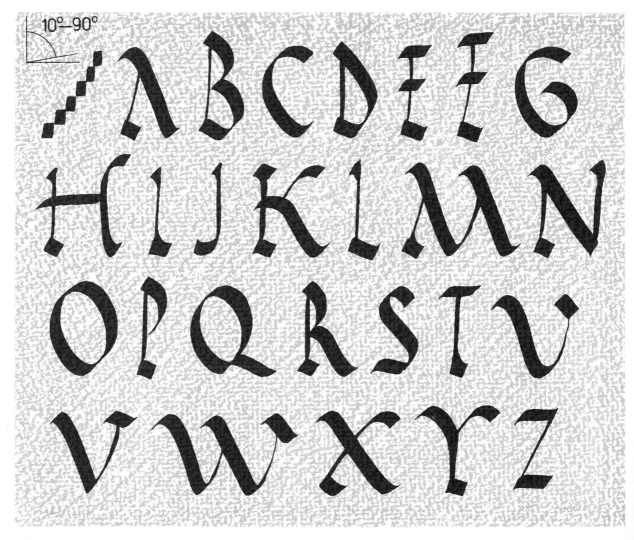

# EMALIG
# NTERAM

The A is usually drawn without a cross-stroke and the L and F are taller to avoid confusion with I and E. The pen angle varies from 10° to 90°. The J has been invented as the Romans did not use it, and the V and W are additions.

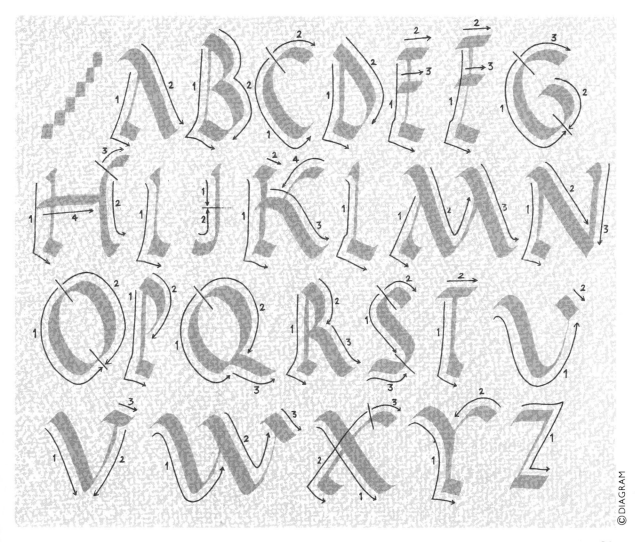

# Uncials and Half-Uncials

The Uncial letterform is extremely ancient; similar letterforms existed in Greece several centuries BC. In the 4th century AD its influence increased in the Roman Empire because it was used for many Christian writings and manuscripts and it became the main book hand. The name Uncial derives from *uncia*, meaning an inch, the height of the earliest examples.

Uncials are formed with full, round counters within the letters; these were derived from the square Roman capitals, but were far more suited to rapid writing. True Uncial is a capital form contained within two guidelines only, with minimal ascenders and descenders, but this was followed by Half-Uncial, the precursor of most minuscule forms. In Half-Uncial certain letters break the top and bottom lines, beginning to form ascenders and descenders as we know them in lower case letters. Uncials and Half-Uncials remained popular until the end of the 8th century, when the Carolingian form swept Europe.

**Examples of Uncial forms**
**1** The first Uncial alphabets emerged as an alternative to the Rustica capitals. 4th-century capitals were of an even height, usually an inch.
**2** Half-Uncials show the beginning of our lower case forms in their ascenders and descenders.
**3** The *Book of Kells* shows the Insular Uncial script, an Irish interpretation of Uncial and Half-Uncial.

**Tools**
Most wide-nibbed pens and chisel-ended brushes can be used for forming Uncial and Half-Uncial; pens will give the clearest outline, but brushes can produce a rather attractive softer feel. Chisel-tipped felt pens will also produce a good Uncial form, although they need to be as wide as possible.

**Proportions**
Antique Uncial is traditionally 3–4 pen widths high (**1**), the letterform is very round and the letters look rather squat. With Modern Uncials (**2**) the tendency is to write faster and create letters 5 nib widths high, giving a more open look. Half Uncials (**3**) have ascenders and descenders so allow for this when you rule up.

## Angles

Antique Uncial forms are produced with the angle of the nib horizontal, or very nearly so; the stress is very upright (**1**). Modern Uncials, following the Celtic trends, are written with the pen at an angle of 10–20° from the horizontal, and the stress is slightly more diagonal (**2**).

# ANTIQUE MODERN

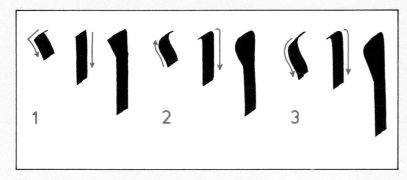

## Forming serifs

Traditionally Uncial hands have wedged serifs, but they may also have clubbed ones. Form the wedged serifs by making one angled stroke and then making the upright (**1**). Clubbed serifs can be formed with a vertical long loop before the ascender (**2**), or by first making a looped, angled stroke (**3**).

## Practice exercises

Several exercises will be very useful for getting the feel of Uncial and Half-Uncial letters. First of all, use a flat piece of chalk on a blackboard and practise the full, rounded counter shapes with the chalk held horizontal and then at an angle (**1**). Also you can use two pencils tied together to see exactly how the strokes are formed and where the stress lies (**2**). Thirdly, use the groups of letters (*right*) to practise getting a uniform feel into the letterforms (**3**); remember that the roundness of the letters and the angle of the pen are all-important. Draw each group over and over again until you are confident.

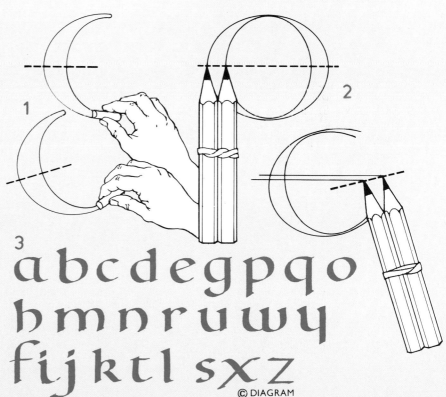

abcdegpqo
hmnruwy
fijktl sxz

© DIAGRAM

# *uncial*

Antique Uncial is written with the pen at a fairly flat angle, to give a markedly vertical stress to all of the letters. You can see how some of the forms of this majuscule alphabet were forerunners of some of the lower case letters we know today.

**Achieving the right effect**
The flattened appearance of the letterforms and their vertical stress is achieved by working them in broad, shallow curves with the pen held so that the nib angle is horizontal.
**1** Holding a flat-tipped nib for Uncial writing.
**2** Holding an angled nib for Uncial writing.

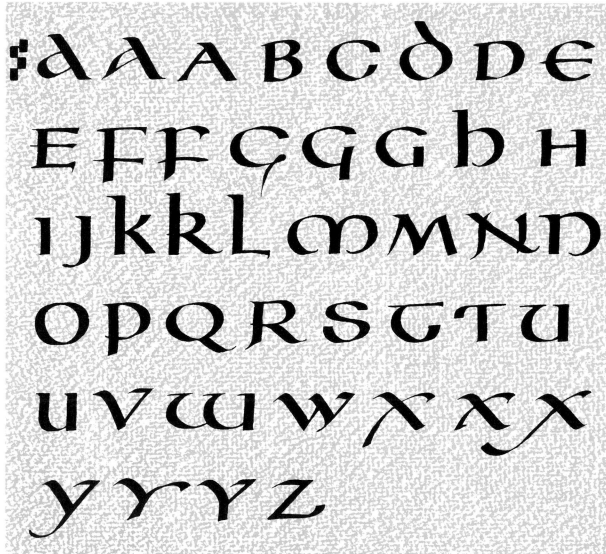

**Variations**
Uncial alphabets with a more modern appearance can be lettered by increasing the ratio of the height to the nib width; these letters were written to a height of 9–10 nib widths.

δεhϻ pqsuv

# *uncial*

Modern Uncial was developed in the 9th century so that it would be quicker to write. This interpretation of the original script was written with the pen held at an angle rather than horizontal and the strokes are tapered away to the left.

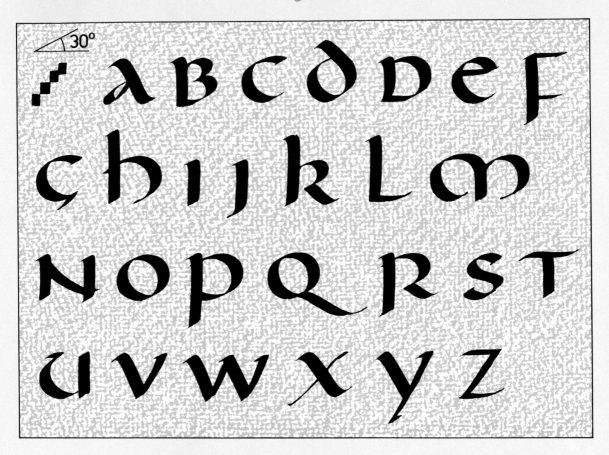

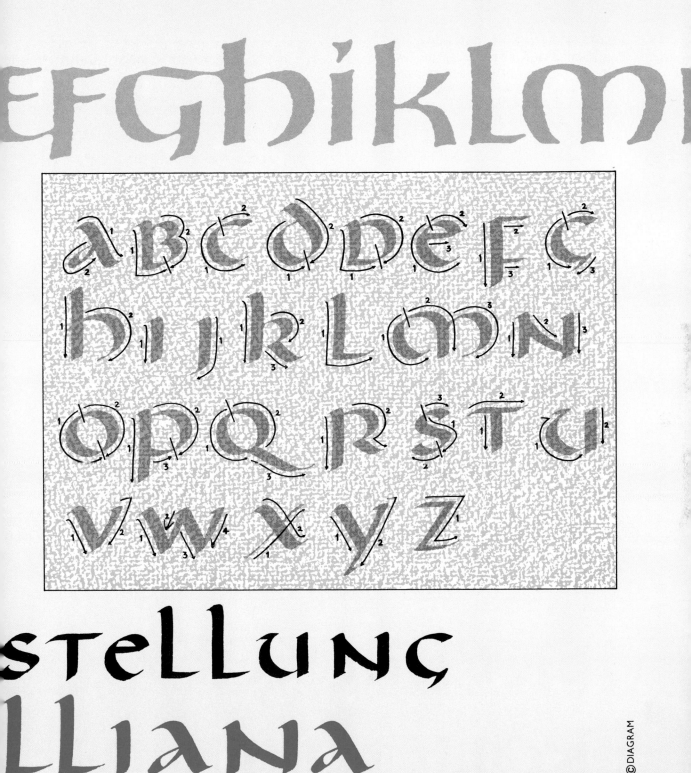

# half-uncial

Half-Uncial seems to be a lower case alphabet but was formed and used as a majuscule. The antique letterform (*below*), written with the pen held at an angle of 5°, was based on *The Book of Kells* (right) written by scribes from about 790–830.

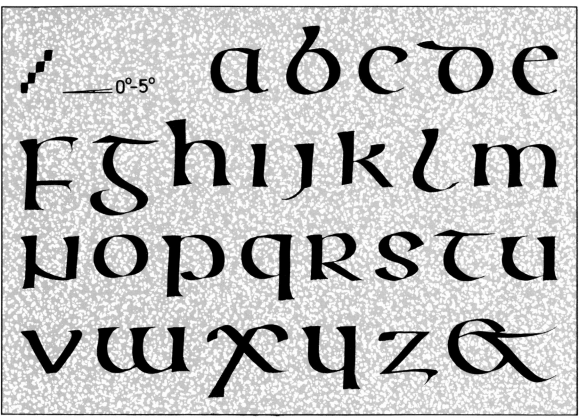

INCERROGABAC

KONTINENTEN

The more modern version (*below*) has very rounded curves, chunky ascenders and descenders. The example (*right*) is Roman Half-Uncial, written in England in the early 8th century, with the pen held horizontally.

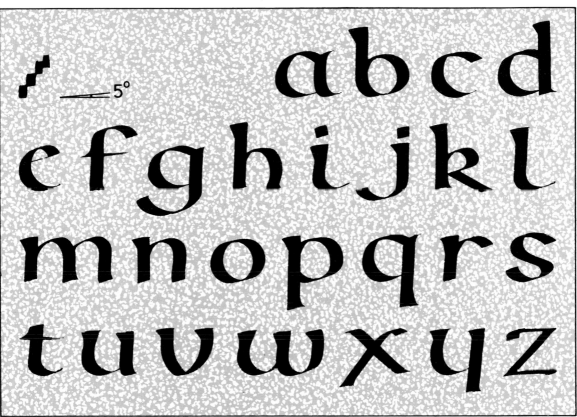

abcd
efghijkl
mnopqrs
tuvwxyz

5°

©DIAGRAM

bokklubben
irish linen

# Versals and Lombardic

Versal letters, and their more decorative Lombardic forms, are essentially initial letters; they are not used extensively in texts. They make a powerful impact used large at the beginning of a piece of calligraphy, or perhaps even for the first word; they were often used in this way in ancient manuscripts. The attractive, open shape and the wide strokes also mean that Versal letters lend themselves very well to decoration. Versals don't have a minuscule form of their own – they were used generally with Carolingian, Uncial and Half-Uncial letters. The construction of Versals is different from the construction of most calligraphic styles, as they are built up from a series of strokes in each direction; the main outline is done first, then filled in. Lombardic forms tend to be very elaborate, often making use of hairline decorations and other details such as small dots or diamond shapes.

### Progression in style
**1** A basic Versal form.
**2** Edward Johnston used Versals in his calligraphy earlier this century.
**3** An example of a more elaborate Lombardic form.

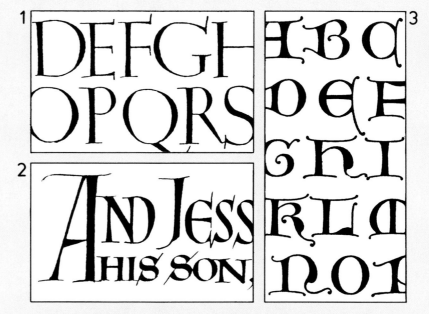

### Tools
Versals can be formed with pen or brush, or with a combination of the two – for instance a pen outline filled in with brush colour. For the outline you will need a fine nib or brush if you want to form the inside in a contrasting colour; if you want to make the letters one colour throughout you can use a wider pen or brush and then fill in with another stroke.

### Instructions
Most Lombardic letterforms are based on a circle, so bear this in mind as you form the preliminary shape. Versals are more upright. Do all the outlines first before you fill in the body of the letter. This lettering style may prove to be harder than some others, as it can be much freer; you will have to do a fair bit of practice to get the feel of the letterform.

## Characteristics

Certain characteristics are common to Versal styles, and will help you to produce authentic-looking letterforms. The straight strokes are waisted; that is, they are thinner in the middle than they are at the ends (1). Versal and Lombardic forms have hairline serifs across the tops of the strokes; again these are slightly curved (2). Crossbars for the H, E, F and A are usually (though not always) positioned just above the middle (3).

## Forming the letters

Each stroke is made in basically the same way whether it is a straight stroke or a curved one. If you are using a brush or a fine pen to form an outline, do the upright sides of the straight strokes first followed by the curved strokes and then the small lines at the ends of the strokes. Then fill in with a colour. If you are forming the whole letter in one colour use a wider pen or brush for the preliminary strokes (1) and then touch in the gaps (2).

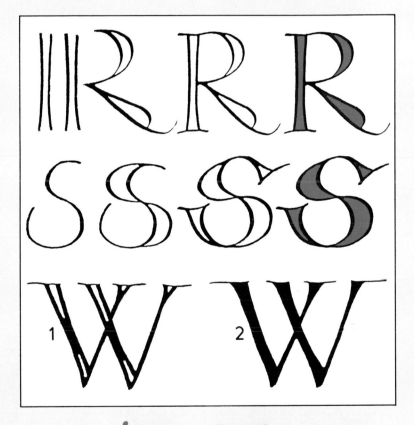

## Decoration

These letterforms, especially the wider, fatter versions, lend themselves very well to decoration. This can be as simple as adding hairlines but you can add swells to the strokes and to the ends of the hairlines or you can add flourishes of all kinds.

# *versals*

This very simple Versal alphabet shows the letterform at its most elegant; the strokes are waisted, and each is formed with two strokes of the brush or pen. The hairline serifs and the characteristic curves of the B, D, P and Q distinguish it as a Versal face.

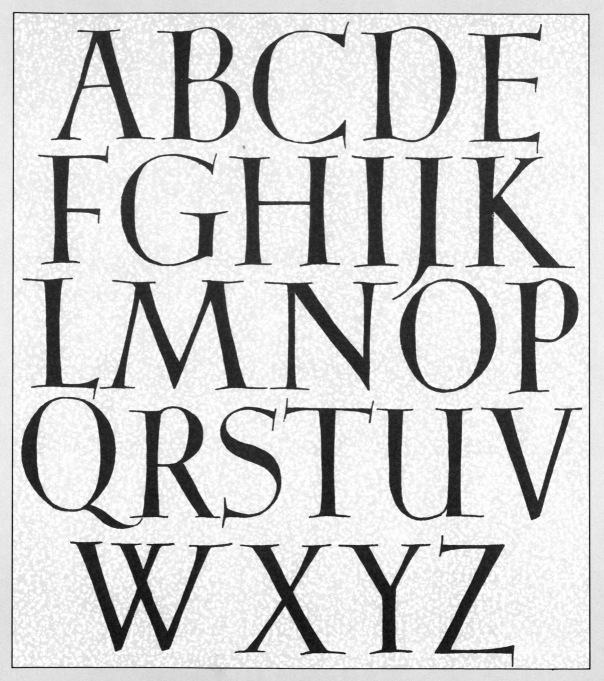

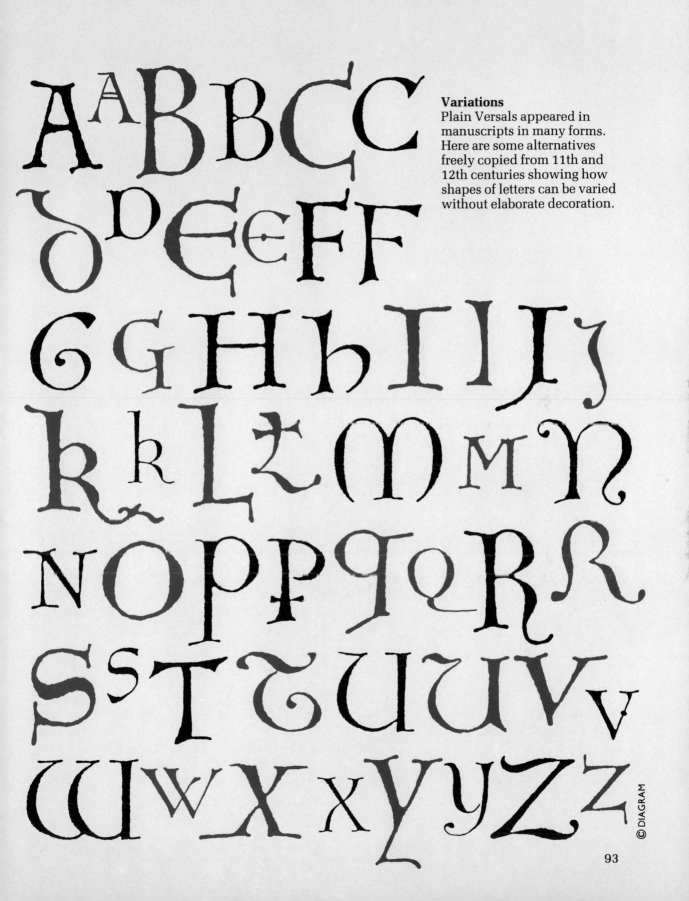

**Variations**
Plain Versals appeared in manuscripts in many forms. Here are some alternatives freely copied from 11th and 12th centuries showing how shapes of letters can be varied without elaborate decoration.

© DIAGRAM

93

# versals

Filled Versals look very special as initial letters or for a small piece of calligraphy. This alphabet is worked in fine pen or brush first in outline form, then filled in with a soft brush in a paler colour.

**Using the brush**
If you are using a brush for the outlines, choose a soft fine one with a good point. Keep the hairs of the brush parallel with the line you are drawing so that the lines stay an even width; this will mean that you need to manipulate the brush, your wrist, and the piece of paper you are working on.

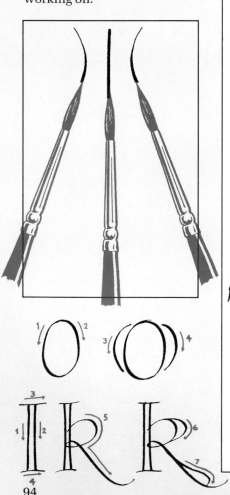

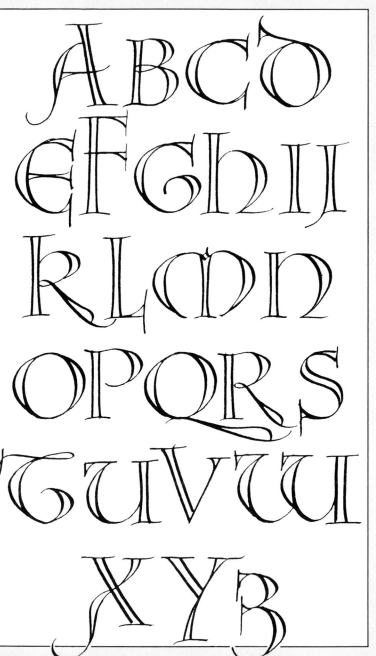

94

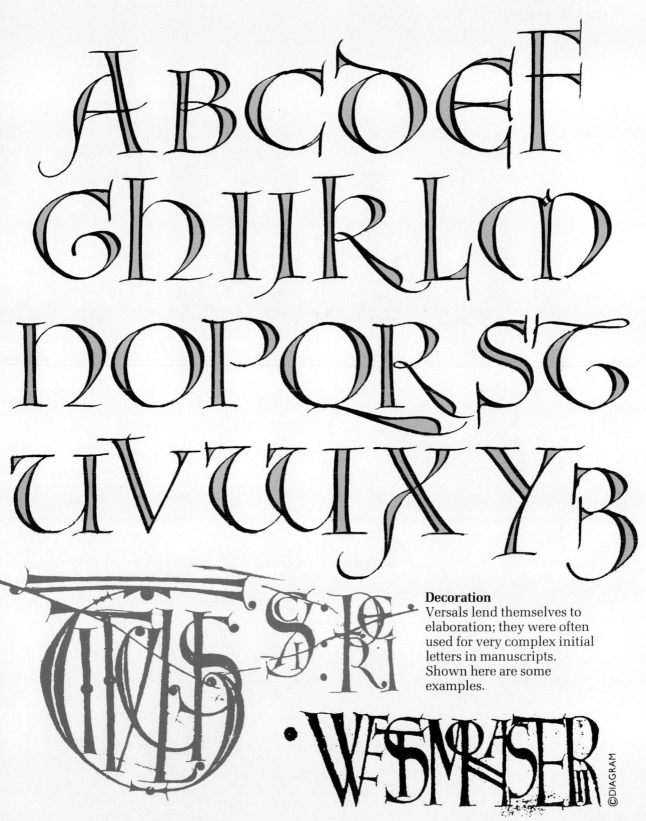

**Decoration**
Versals lend themselves to elaboration; they were often used for very complex initial letters in manuscripts. Shown here are some examples.

# versals

Shown here are three very different Versal faces. The elaborate German capitals (*below*) are decorated with flourishing swells, serifs and hairlines. The plainer 16th-century Spanish letters (*bottom*) have elegant waisted strokes and exaggerated hairlines.

The freely drawn Versal alphabet (*right*) shows how you can be inspired by the work of other calligraphers.

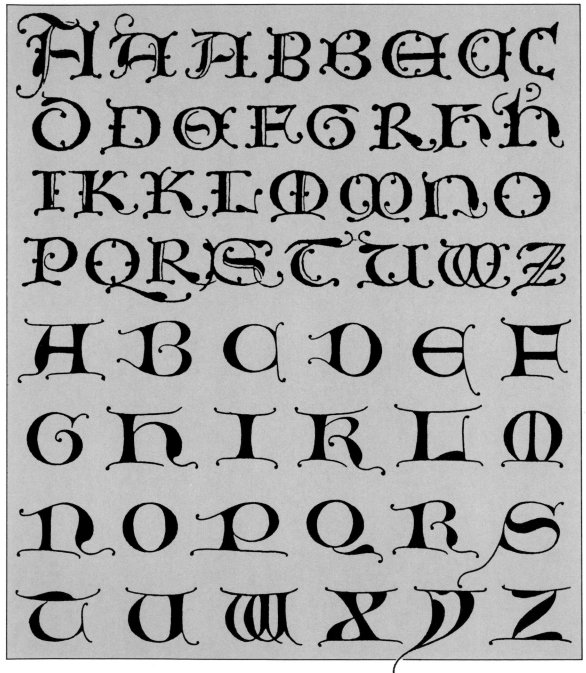

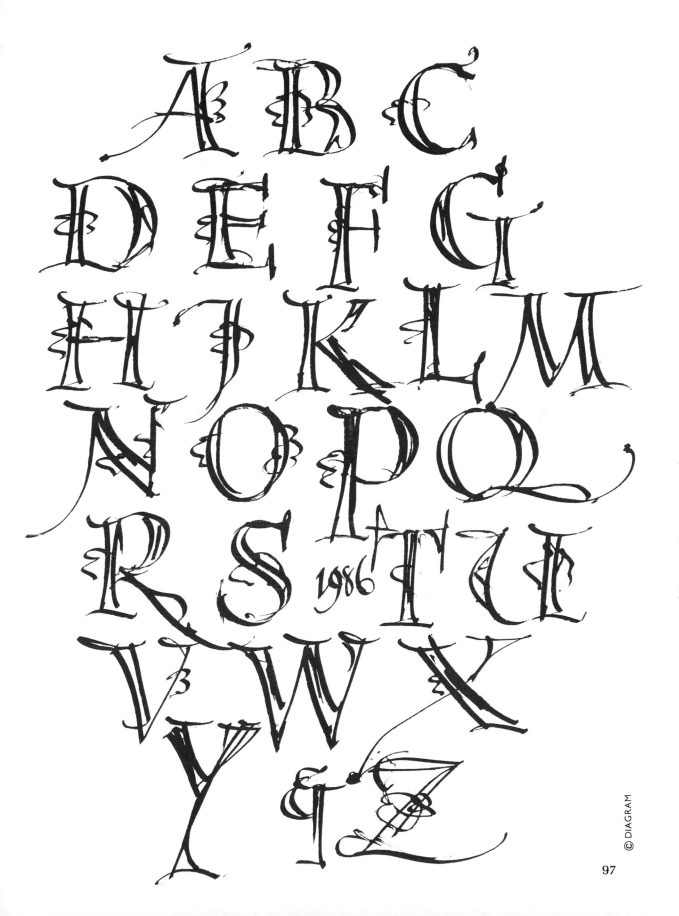

© DIAGRAM

# Gothic

During the 11th and 12th centuries in Europe the graceful style of writing became increasingly formalised and regular, and developed a heavy, dense appearance which led to the name Black Letter which is applied to some Gothic faces. Many different forms of the script, both formal and informal, appeared during the 13th and 14th centuries, as scholars and businessmen moulded the writing to suit their own needs and preferences. Gothic letters are angular and heavy, with short ascenders in relation to the body height; the name Gothic was given to the letterform by Renaissance scholars who thought the style was so appalling that they named it after the barbarian Goths. In some areas the letterform became angularised to the point of absurdity, making it virtually illegible; in other areas the letterform became more rounded, particularly in Italy where the style was known as Rotunda.

### Different styles
Several different schools of Gothic lettering are illustrated in these examples.
1 Textura quadrata, characterised by its diamond-pointed feet and forked ascenders.
2 Gutenberg 42-line Bible; quadrata was taken as the printers' model for early type design in northern Europe.
3 Rotunda, a more cursive interpretation of Black Letter.

### Tools
Any broad-nibbed pen is suitable for Gothic lettering. You can use a dip pen, one with a reservoir, or a fountain pen; many of the sets of pens sold for Italic handwriting are suitable if you attach the widest nib. Also chisel-pointed felt pens, split-nibbed felt pens and ordinary pens, are very effective for Gothic lettering.

### Instructions
The stress of Gothic lettering is angular. The letters are formed with a combination of fine lines made along the angle of the pen, and much broader strokes as the pen moves in other directions (1). Extra hairlines are made by lifting the corner of the pen and dragging a little ink out into a hairline extension (2).

### Proportions
Gothic letters have very short ascenders and descenders, so draw your guiderules accordingly (3). The spacing of the very dense letters allows the same amount of space between letters as the letters have internally, so the finished lettering has a very even and neatly textured appearance.

# practice or design

**Practice exercises**
In your sketchbook, practise making blocks of the same letters and letter combinations over and over again until you can do them evenly.

**Capitals**
There is no standard capital alphabet for Gothic letterforms; each area and era simply used the styles that they felt were most appropriate. Quite often the capital forms are far more rounded than the

minuscules, but this doesn't matter; the main strokes can be formed in just the same way as the main parts of the smaller letters. Form the hairlines by holding the pen flat at the required angle and drawing it along in a straight line.

o e c a a a
b d p q g v
m n v u w
h k l r f t i j
r s l z w

GOTHIC

GOTHIC

GOTHIC

BLACKLETTER

©DIAGRAM

99

# gothic

Gothic alphabets are enormously varied as there were no standard forms and they were influenced by many different design ideas. These have been adapted for legibility.

**Clarity**
The height of this capital alphabet is 6 nib widths to make it clearer. Feathering and hairlines are strong features. The lower case alphabet is simplified from an old form, which also makes it more legible. The basic Gothic form (*below*) shows how difficult it can be to read a condensed script.

# gothic

The Gothic Black Letter lower case alphabet (*below*) has short ascenders and descenders, so lines could be spaced closer together. The capitals (*far right*) are quite small but they are rounded to distinguish them from the angular lower case letters.

**Forked ascenders**
Write the down stroke (**1**) holding the pen at an angle of 40°. Then turn the pen to 90° to go up (**2**) and bring it down and add the hairline with the edge of the pen (**3**).

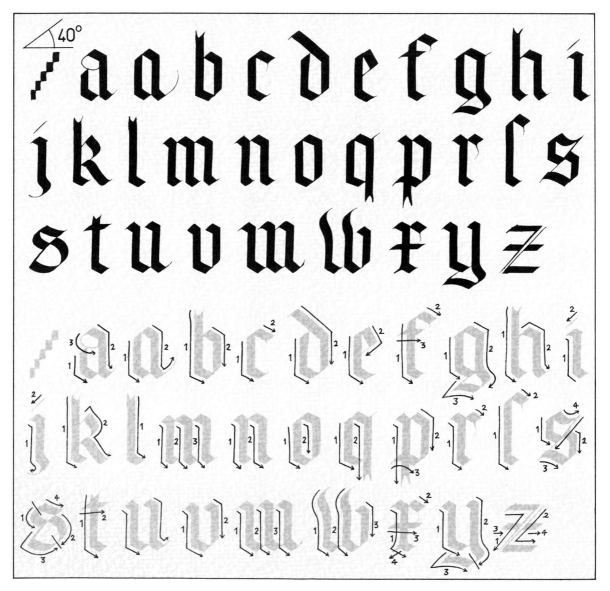

*gothic*

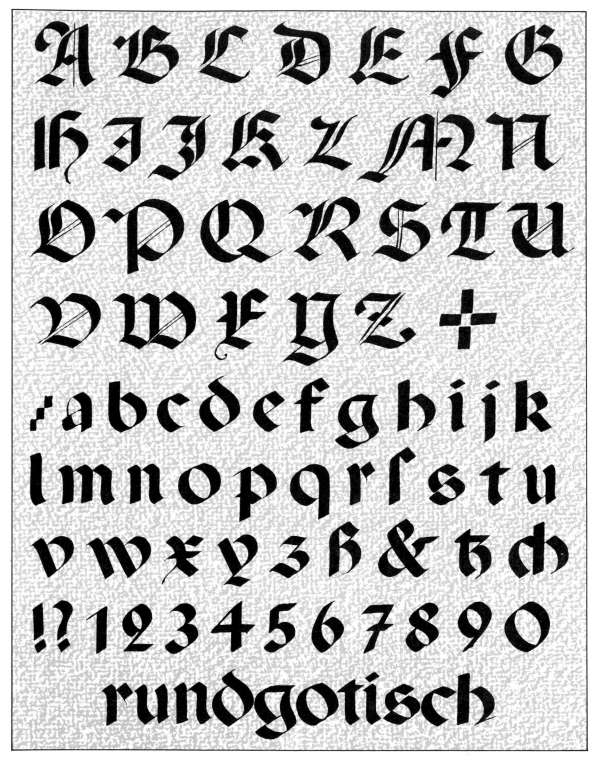

The Rotunda influence can be seen in the lower parts of these letters but the Gothic pointed image is still visible as the eye reads the top of letters. The angle of the pen has to be turned to write these alphabets.

# gothic

The lower case alphabet (*right*) is commonly known as Textura and was widely used in prayer books and psalters. The capital alphabet (*below right*), with angular hairlines, feathering and diamond-shaped serifs, could be used with it.

a b c d e f g h i
l k m n o p q r z
s s t u u w x y z

A B C D E
F G H I K
L M N O P
Q R S T U
W X Y Z

minimum

minimum

minimum

minimum

## Spacing
A happy medium is required in spacing Gothic letters. The example (*left*) shows how spacing alters the legibility of a word but also affects the rhythm and pattern. With no spaces between letters it is difficult to read, but with too much space the word becomes ugly. Use minimum as a practice exercise and check your rhythm and pattern by turning your writing upside down and reading the pattern, not the word.

coffee wood

texture quadrata ⁂

quite easily becomes

illegible particularly

## Variation
The examples (*left*) show how, by leaving off serifs and stretching the x height of letters, legibility can be increased.

WICHTIG

## Capitals
The examples (*left and below*) show how difficult it is to read Gothic capitals.

JUGENDHERBERGE

# gothic

ABCDEFGH
IKLMNOPQ
RSTUVXYZ

abcdefghi
klmnopqr
ſstuvwryʒ

abcdefghijklmn

108

The two alphabets (*left*) show the many variations on Gothic letterforms. The early 16th century capital alphabet by Albrecht Dürer has unusual curves and is decorated with diamond shaped dots. The lower case alphabet (*below left*) is long and upright but once the proportions have been learnt can be written smaller.

These modern adaptations of Gothic lower case alphabets (*below and bottom*) show an informal and lively mixture, with hairlines, sharp tops but with oval proportions, longer descenders and ascenders and flowing tails, which make them more legible.

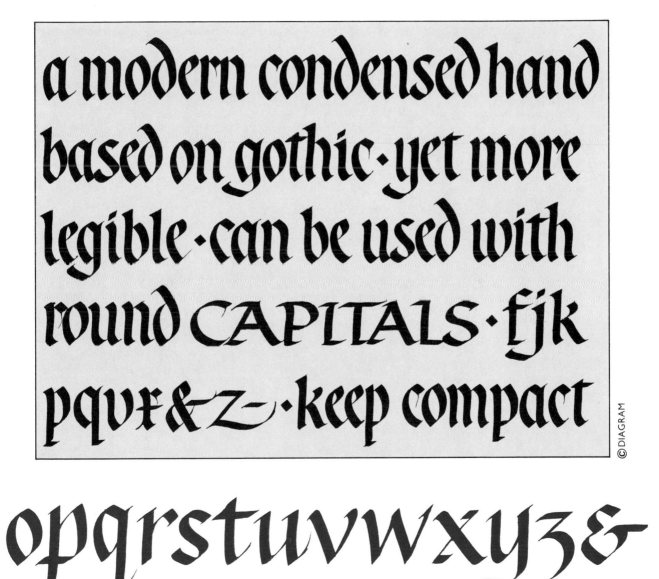

a modern condensed hand based on gothic · yet more legible · can be used with round CAPITALS · fjk pqvr&z– · keep compact

©DIAGRAM

opqrstuvwxyz&

# Carolingian and Humanistic

Carolingian minuscule was a fusion of several different hands from various countries in Western Europe, all of which were in turn based on a mixture of classical Roman and cursive. Generally, the emergence of the Carolingian form is attributed to Alcuin of York, who was sent in 789 by Charlemagne to supervise the school at the Abbey of St Martin in Tours; he was instructed to standardise the various forms of minuscule script that were around. The Carolingian minuscule took root in France in the 9th century and then spread to Italy, England and Spain.

This script is the first genuine lower case alphabet, with long ascenders – characterised by the slight clubbing at the top. There was no capital form in the Carolingian hand; Roman square capitals were generally used with it. From the basic Carolingian style all the elements of modern handwriting developed; the forms have remained essentially unchanged even though they have been modified for speed, consistency, clarity, etc. Carolingian can be formed with any medium-width flat nib.

**Progression of style**
**1** One of the precursors of Carolingian minuscule, the East Frankish style of the 8–9th centuries.
**2** An example of Carolingian from a 9th-century manuscript.
**3** An example from a Tours manuscript.

**Proportions**
Carolingian minuscule needs a high ascender line and a low descender line to allow for correct proportions. The whole letterform is about 15 nib widths in height, but the x height is only 3–3½ nib widths. The letterform is made with the nib held at an angle of 35–40°.

**Serifs**
The serifs of Carolingian hands are clubbed; the effect is of a long blob at the top of each upright stroke. The clubs are formed by making a hooked downward stroke (**1**) followed by the beginning of the upright stroke (**2**).

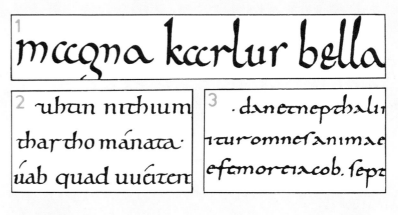

110

Humanistic script was the script influenced by the so-called humanistic scholars, who were part of the Italian Renaissance and who revived an interest in classical Rome. The inscriptions on tombs, triumphal arches and columns seemed to them to be the archetypes of beautiful lettering, and they looked for a suitable minuscule script to go with the classic Roman majuscules. The closest they could come was the Carolingian minuscule, which they felt had the same qualities of openness and legibility, so they adopted the hand, with their own modifications, and called it *littera antiqua* – 'ancient letter'. The style was taken up by the early printed books of Aldus Manutius – it was far more legible than the Gothic hands that were used as inspiration by some other type designers. Other Humanistic forms were the Chancery cursive and, eventually, the Italic; these forms were used by classical writing masters such as Ludovico Arrighi and Niccolo Niccoli. Like Carolingian, Humanistic hands can be done with any medium-width nib.

### Progression of style
**1** An example of an early Humanistic letterform from the 15th century.
**2** Cancellaresca, a more cursive Humanistic script.
**3** Later 15th-century typefaces such as this were based on Humanistic forms.

### Proportions
Humanistic letterforms have a larger body proportion than Carolingian styles; the overall height is about 10 nib widths, and the x height takes up about 4½ of those. The nib angle is about 35–40°.

### Serifs
The serifs of Humanistic scripts are more wedge-shaped than the clubbed serifs of the Carolingian hand. Form the serifs by taking a small angled stroke first (**1**) then completing the top of the ascender by starting the vertical downstroke (**2**).

# *carolingian*

The Carolingian hand is the first example of a true lower case letter; one that has very marked ascenders and descenders, and cannot be contained between only two guide rules. The ascender height is very great; the bodies of the letters look small and rounded in comparison.

**Strange s**

The s of true Carolingian hands is a very strange letter to modern eyes (**1**); it was formed in this way as a conventional s has to be made in several strokes at this angle. If you are lettering in the Carolingian style you could use a more modern s form (**2**) without it looking too strange, and to avoid confusion with the r.

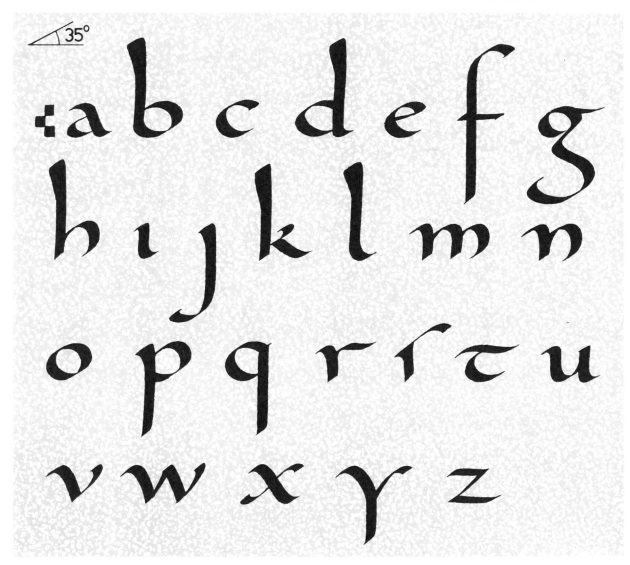

## Capitals

The Carolingian alphabet does not have an upper case; it can be combined with various forms and still look authentic, as the scribes tended to use the capital form that was in vogue at the time. Try modified Roman, Versal or Uncial forms.

Nature Many Menu Tom Notes Never

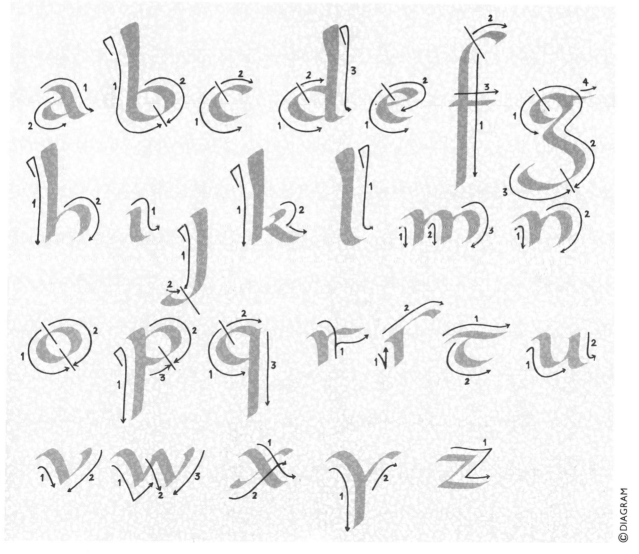

# carolingian

abcdef
ghijklmn
opqrs∫tu
vwuuxyz

45° abcdefghijklm

long ascenders
and descenders
need space

**Variations**
These pages show some
different versions of the
Carolingian alphabet. A
simple version (*far left*) has
shorter ascenders and
descenders. The elegant
modern lower case form
(*bottom*) has an oriental feel
and the imaginative
majuscule alphabet (*below*)
could be used with it.

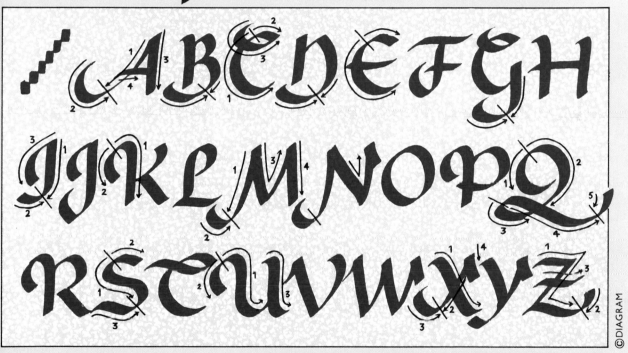

nopqrstuvwxyz

# humanistic

The Humanistic hand was a short-lived hand that linked Carolingian and Italic forms; in this modern interpretation of a classic Humanistic hand you can see both influences.

**Standard shapes**
Although the Humanistic hand did not survive for very long as a calligraphic letterform, it provided the model for many of our most 'classic' typefaces, and also for the basic lower case alphabets that children learn in schools.
**1** Humanistic letter.
**2** The typeface Bembo, one of the earliest faces to be designed after the invention of moveable type.
**3** The typeface Palatino, a modern face showing many of the same characteristics of Humanistic letterforms.

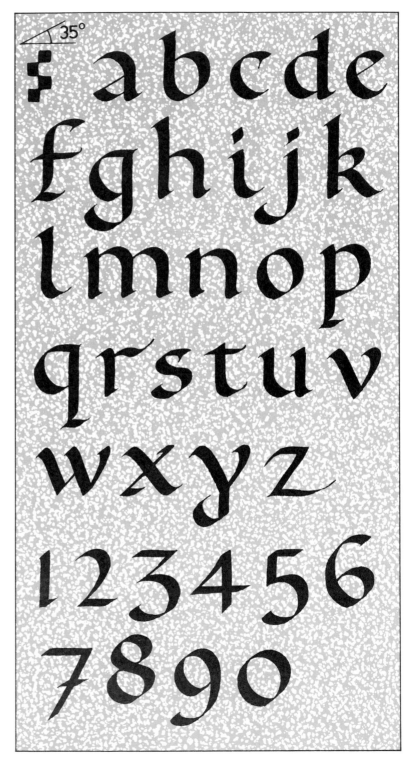

abc **1**

abc **2**

abc **3**

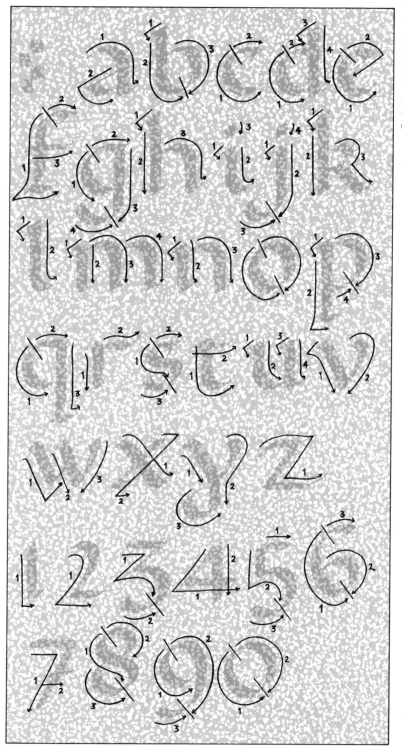

### Variations

There were many variations of the Humanistic letterform, but all showed the same rounded counters and slanted stress. Some, such as the examples here, retained more of the clubbed serif of the Carolingian hands.

bdh
kln
ty

nacht
pasta
radishes
musik

# Italic

The Carolingian hand was somewhat slow to do, although it was very beautiful and clear; after a while it began to develop more cursive tendencies as people looked for ways of speeding up the letter formations. This cursive version eventually became a style in its own right, the Italic style. Italic writing has often been advocated in recent years as the lettering style that gives the best combination of legibility and ease of execution, and it is now the basic handwriting style taught in some schools. The early 20th century saw a revival of Italic lettering, especially through the work of Edward Johnston

and Alfred Fairbank; good handwriting was seen as something desirable, and the Italic style was one of the easiest models to copy. The most obvious characteristics of Italic hands are the marked slant of the letters to the right and the diagonal stress of the letterforms; although there are many very personal interpretations of Italic handwriting these characteristics are evident in them all. One of the most desirable features about learning Italic as a calligraphic hand is that it is also easy and practical to use it as an everyday handwriting style as well – so you can keep in practice!

### Progressions in style
**1** The characteristic slant of the letters in Italic can be seen in this early 16th-century example.
**2** Johnston's Italic hand shows the letterform's elegance.
**3** A writing example from one of Fairbank's lettering manuals.

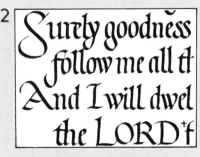

1 *che picol sia, che al meno e glie e p sempre'efsere'al modo gran testimonio della dinotione'mia uerfo di uostra Magnificentia. Alla buona gratia della qualle humilmete*

2 Surely goodness follow me all th And I will dwel the LORD†

3 ove, which reachest but to du ty mind, aspire to higher thin at which never taketh rust: les. but fading pleasure bru ms, and humble all thy mi

### Tools
To show Italic handwriting off to its best advantage, you need a pen or other implement that has a broad tip, so that you can achieve a good contrast between the thick and thin strokes. Straight or angled nibs can be used with dip pens or fountain pens, or you can try out some of the chisel-ended felt pens or brushes.

### Writing instructions
Most Italic writing is done at a slant of 5° from the vertical and with the pen at an angle of around 45°; once you have developed your own style you may prefer to alter this a little nearer the horizontal or the vertical. However, with correct Italic letterforms this will give you maximum speed and stroke contrast.

5° mnopq
rstuvw
45°

### Different styles
There are several different characteristics within the Italic family of hands, one of which is the emphasis on the ascenders and descenders which can vary quite considerably.

### Proportions
Italics, even plain styles, can be written with quite elaborate flourishes, so you will have to allow for this when you are ruling up. Once you begin to try out different styles you can vary the proportions between the x-height and the lengths of the ascenders and descenders to give different effects.

### Linking lines
Italic letters lend themselves very well to being linked with hairline strokes called ligatures; as the movement of the pen is diagonal anyway, it is easy to leave the pen on the paper. However, if you prefer to form each letter separately this is perfectly acceptable, and makes the final result somewhat more formal.

*universam* [1]

*universam* [2]

### Practice exercises
Use these line patterns to practise forming the strokes needed in Italic hands; check constantly to see that you are holding the pen at the correct angle.

©DIAGRAM

119

# *italic*

These upper and lower case alphabets show the basics of the letters and it is essential to practise these before attempting swashes and flourishes. Studies of examples from Italian masters such as Arrighi (right) show that the writing should be free, rhythmic and spontaneous and flourishes a natural extension of the letter.

*benignissimo Lettore, che riguardo bauendo al-la publica utilita e comodo non solamente' di*

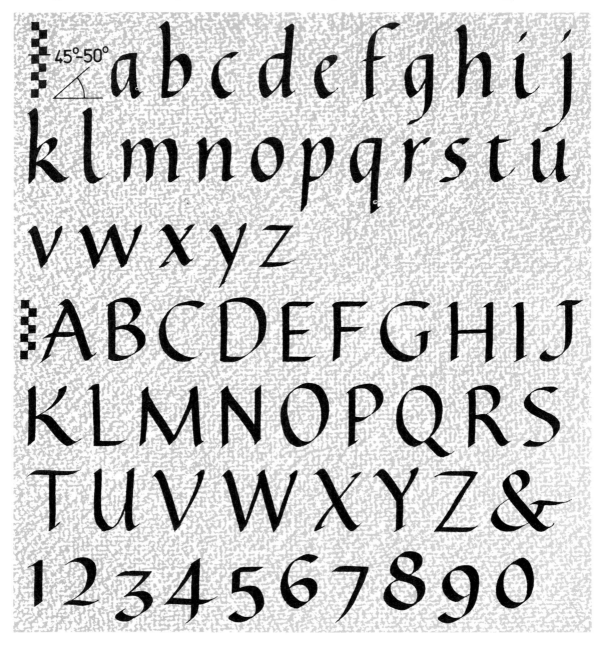

# bfgkqvwxzy

**Variations**
Once you have mastered
keeping the ascenders and
descenders even and regular,
you could try some of the
variations (*left*).

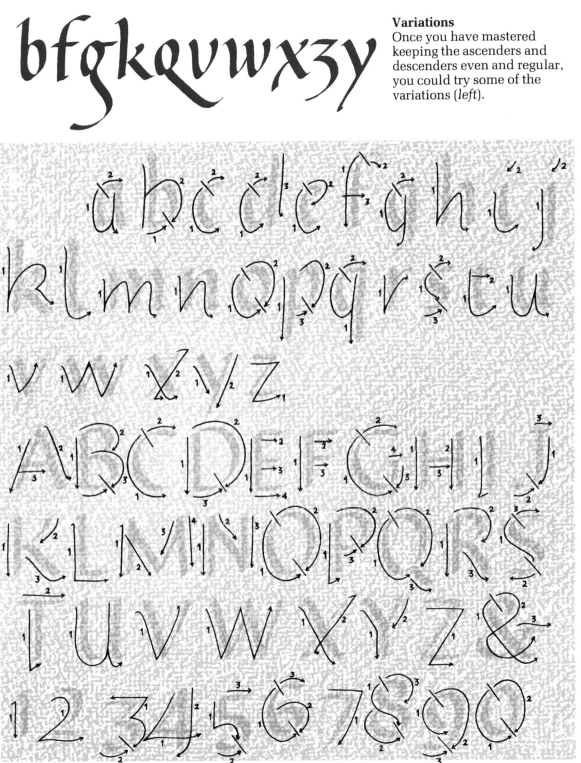

*italic*

ABCDEFGHIJ
KLMNOPQRS
TUVWXYZ&

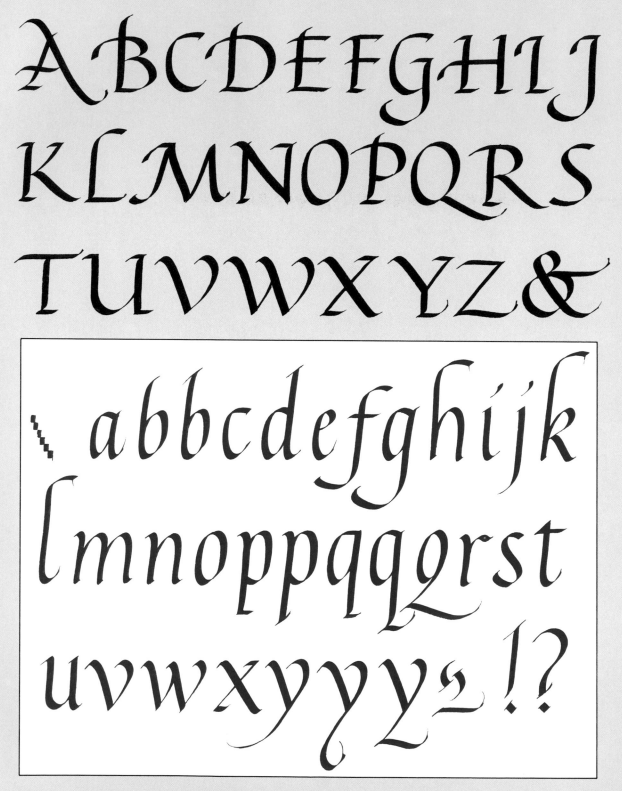

`abcdefghijk
lmnoppqqqrst
uvwxyyyyₑ!?

abcdefgh
ijklmno

Italic letterforms are numerous, although they are all variations on the same theme. The letters are formed in just the same way as the examples on previous pages, but each of these faces has its own characteristics. The elegant upper case alphabet (*far left*) is the basic Italic with added flourishes.

The lower case alphabet (*far left*), with its x height increased to 6 nib widths, gives a light, elegant hand ideal for flourishes.

pqrstuv

In contrast the lower case alphabet (*left*) is spikey and angular with hairlines on some ascenders and descenders.

wxyz &

vite!

© DIAGRAM

mes compliments

123

∡45°

abcdefghijk
lmnopqrstuvwx
yzß&&ſt

ABCDEFGH
IJKLMNO
PQRSTU
VWXYZ

*Abbreuiature*

The beautiful upper and lower case alphabet (*far left*) has fairly ornate capitals with flourishes and the lower case letters have hooked ascenders, hairlines and soft finishing strokes.

Giovanni Battista Palatino was one of the writing masters of the 16th century who developed the cancellaresca style. The examples (*left and below*), with an enlarged detail (*bottom*), are from Palatino's *Libro Nuovo* published in 1540.

125

# italic

Always use words or names in alphabetical order when practising flourished capitals. The choice of flourish will depend on the opportunity that arises from the collection of letters making up the word, the position of the word on the line, and whether it is the top or bottom line. Each opportunity is unique and it is important to experiment. Use large nibs so the faults can be seen more clearly and concentrate on rhythm and spacing. Copying poems or quotations is a useful exercise.

A A A Anne

Diana David E Ed

Giotto George Henr

Kirsten Kate Leo

O Pedro Penny Que

yes Santa Tio Theo U

x·x Yes Yoko Y

Italicrhythmfull

Ben Benny Bella Carl Carla
die Elizabeth F F Françoise
Harriet H· Hans Jan Jane
Maria M· Mo Nicki Ned
n Qu Rimini Rio San
trillo Vanya W· Wilhem We
& & Zed Z·
unique sherriff fun

# Roundhand

In the 16th century copper engraving began, and this influenced a more delicate linear style of lettering, with fine flourishes and swelled lines, that imitated the strokes of an engraver's burin rather than those of a flat-ended nib. An Italian *Bastarda* hand, introduced in a writing manual by Giovanni Francesco Cresci in 1560, marked a definite break with previous writing traditions; the new style was flowing, looped, and could be produced without lifting the pen from the paper.

Adaptations of this 'roundhand' spread over most of Europe (the main exception being Germany, who retained the Gothic form); the basic hand was speedy and practical and was quickly adopted for commercial work such as ledgers and instruction books. The style, although basically simple, did allow for a great deal of ornamentation, and at times, especially in writing manuals, was developed to excess.

## Style development

Cresci's basic letterform, characterised by swelled lines and loops combined with the 'Italic' angle of writing, foreshadowed the elaborate loops advocated by copperplate writing masters of later centuries.
**1** Cresci's *Bastarda* style
**2** Classic copperplate in a simple form
**3** Highly ornamented copperplate

## Tools

Copperplate and the other rounded hands are formed at a marked angle, and you will need the right tools to enable you to make the letterforms in the right way. In order to achieve the angle, you can use either an angled nibholder or an elbow-angled nib; these enable you to keep the handle of the pen straight while forming slanted letters. Although some parts of the strokes are thick, they are formed by pressure on a fine nib rather than by a wide nib.
**1** Nibholders with angled attachments
**2** Mapping nib; fine-pointed ones are suitable for the rounded hands
**3** Crow quill nib
**4** Elbowed copperplate nibs

## Angle of writing

The rounded hands are written at an angle of roughly 36° off the vertical, or 54° off the horizontal. The penholder itself is held straight, and the elbow angle of holder or nib provides the slant. Practise keeping the slant even on all the letters.

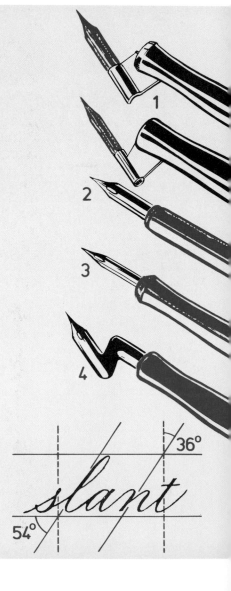

### Proportions

The proportions of classic rounded hands can be broken down just as geometrically as classic Roman ones, as the example (**1**) shows. Generally, though, you can take a more relaxed approach to the writing! The letterform is quite high compared with its width, and copperplate has two ascender lines (**2**), one for flourished or looped ascenders and one for the plain straight ones. Some of the earlier writing masters made their ascenders and descenders very long and pronounced, filling in the loops as a solid (**3**).

*2 abcdefghiklmn*

*3 com desejos a ellas senão applica;*

*Car tout ce qui auient pour le regard de*

### Strokes

The strokes in Roundhands are divided into four kinds. These are most obvious in copperplate, but are evident in the other Roundhands too. Part of the letter is formed with hairlines (**1**) as the nib travels across the paper.

When pressure is applied the nib widens and forms swells (**2**) that begin and end in hairlines, or shades (**3**) that are strokes with squared ends. Connectives (**4**) are hairline joins between letters, a common characteristic of Roundhands.

*Round*

### Practice exercises

These exercises will help you to develop the different strokes and techniques needed for good Roundhands; do each exercise over and over again in your notebook until you can keep all of the strokes consistent.

# roundhand

Shown here are traditional Roundhand upper and lower case alphabets. Many of the letters are formed in one stroke. The downward strokes are thick and, to give them more grace, you should start lightly, apply pressure and then release the pressure before you complete the stroke. The upward strokes and swells are thin hairline strokes. The curves should be round and equal and the loops the same size and shape.

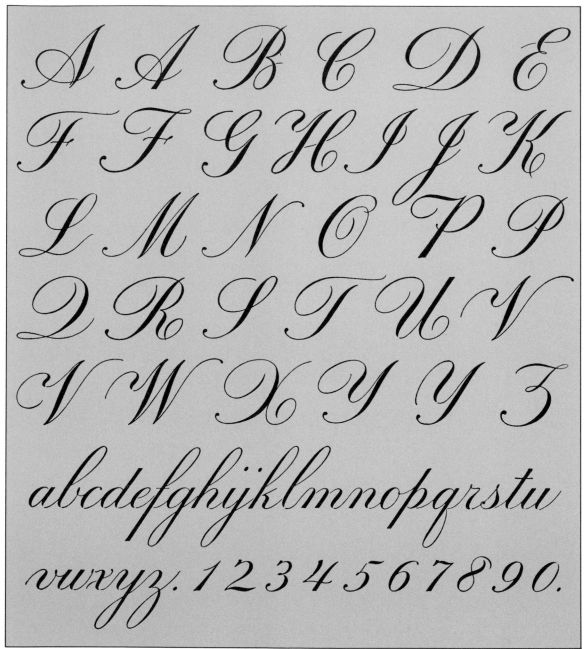

© DIAGRAM

# roundhand

A more flourished Roundhand upper case alphabet with extra swashes made by careful pen manipulation. The lower case alphabet, however, has much with plainer ascenders and descenders. Note the strange formation of the w.

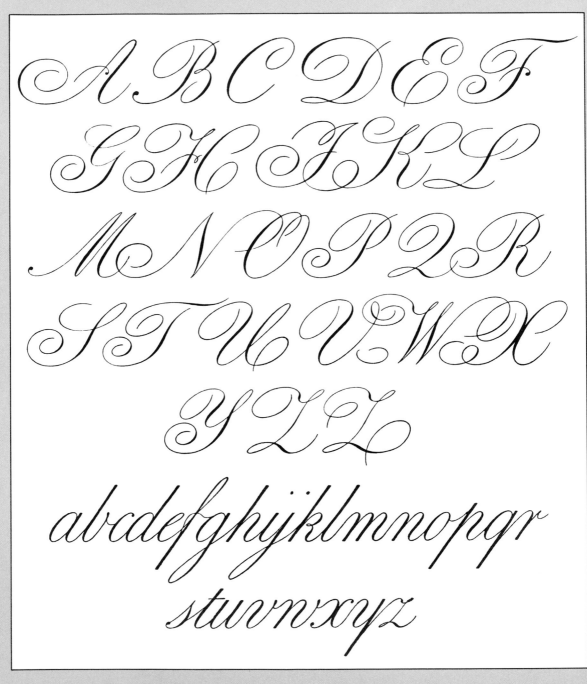

**Variations**
These examples from the
early 17th-century writing
masters show some very
elaborate flourishes which
require a great deal of space.

TO THE READER

Ad Doctiss Clariss.imumq; Virum Dnu Petrum
Carpenterum Scholæ Rotterodamensis Rectore
Vigilantissimum.

Non levis est operæ moderari fræna Juventæ,
    Adque Aganippæi ducere fontis aquas
Sentit qui ludi maculatur pulvere, sentit
    Inter curratos qui tonat ore choros.
Hoc, Carpenteri, nec tantum hoc optime præstas,
    Dum nullum frustra tempus abire sinis.
O te felicem cerebri! tibi scribere ludus
    Quodque opus est alijs hoc tibi præter opus.

*(fragment in framed panel)*
...e gl'amici ... lessan...
...tita di danari ... marita...
...to più di Cinquanta talen...
...a disse Porillo, dicci

N LETTRE facile à jmiter pour les femmes.

Nous deuons peser et estimer les biens et faueurs que nous receuons de

Dieu, auec nos biens temporels, beaucoup plus que tous les maux qui

nous sçauroient aduenir.

LETTRE RALENTIE FORMEE
Dit Les Vitesses de L'Ecriture

Tous les plus grands biens du monde sont parsemez d'ennuits et de sollicitudes

et n'y a condition en la vie humaine plus redoûtable que la prospere. Pour garantir

133

# Unusual calligraphic alphabets

This alphabet by Arthur Baker was written with black ink using a Coit pen. Great skill is required in pen manipulation to achieve the distinction between the thick and thin strokes. The original size is 30.5 × 40.5cm (12″ × 16″).

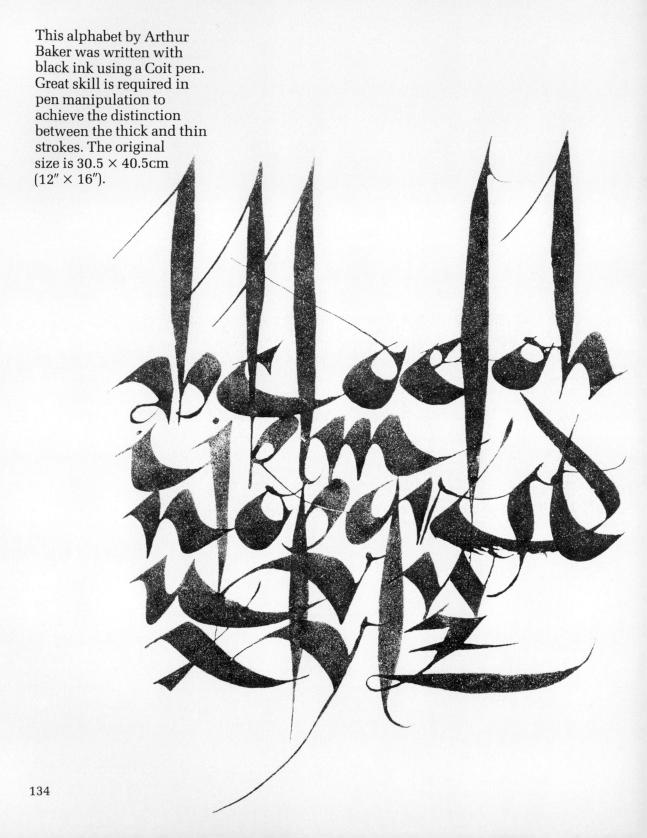

This freely written modern Roman alphabet, by Anne Trudgill, was written with pen and ink. The original height of the letters is 4.5cm (1¾").

A B C
D E F G H I J K
L M N O P
Q R S T U V
W X Y Z

# *unusual calligraphic alphabets*

This Greco-Roman alphabet by Alan Blackman was written with a bamboo pen on bond paper. The original writing is 3.4cm (1⅓″) high.

ABCDE
FGHIJK
LMNOP
QRSTU
VWXYZ

A modern simple line alphabet drawn with a square-ended felt tip pen. The letters touch each other so the eye is aware of the spaces within and the effect is similar to looking at a stained glass window.

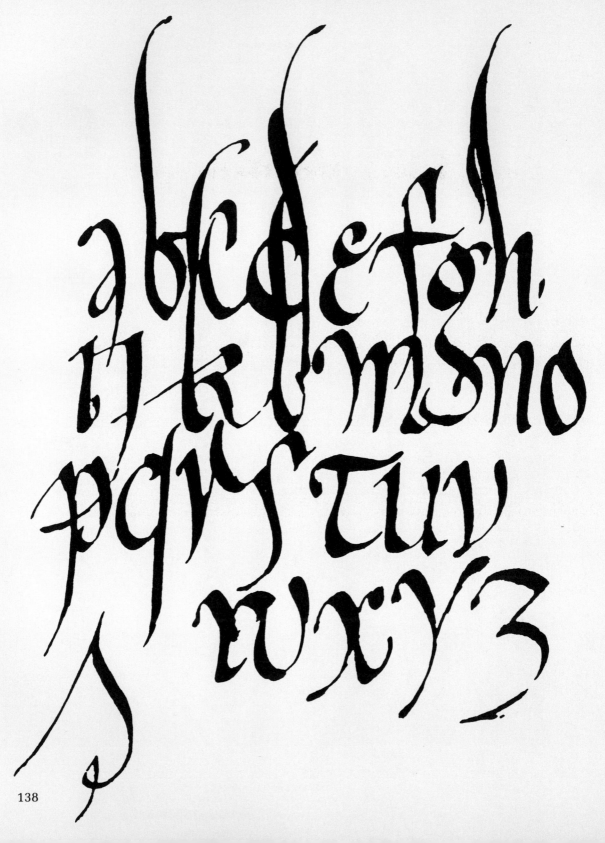

Two modern alphabets by John Fitzmaurice. The alphabet (*left*), influenced by early Merovingian scripts of the 9th century, was drawn with a broad nib at 20°. The letters are condensed but have exaggerated ascenders so a great amount of space is required between the lines. The freely developed alphabet (*below*) is based on the Celtic Uncials. It was drawn with a broad nib held at 15°. This style gives a maximum amount of flexibility for wide open counter spaces within the letters.

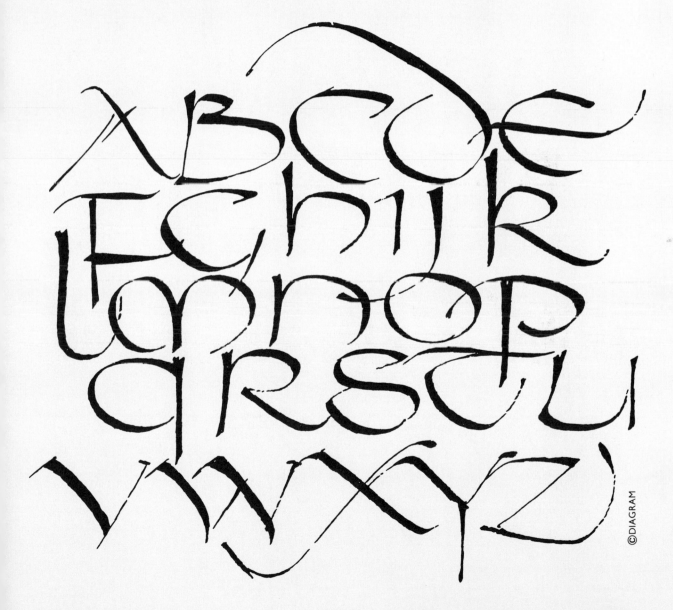

# unusual calligraphic alphabets

This humorous and inventive alphabet was created by graphic designer Roger Kohn. The irregularity and absence of structure emphasise its distinctiveness.

The freely written alphabet by Robert Boyajian (*far right*) was written out in sepia and black India ink mixed, with Lozada brass pen on Hammermill Bond. The original size is 43 × 35.5cm (17″ × 14″).

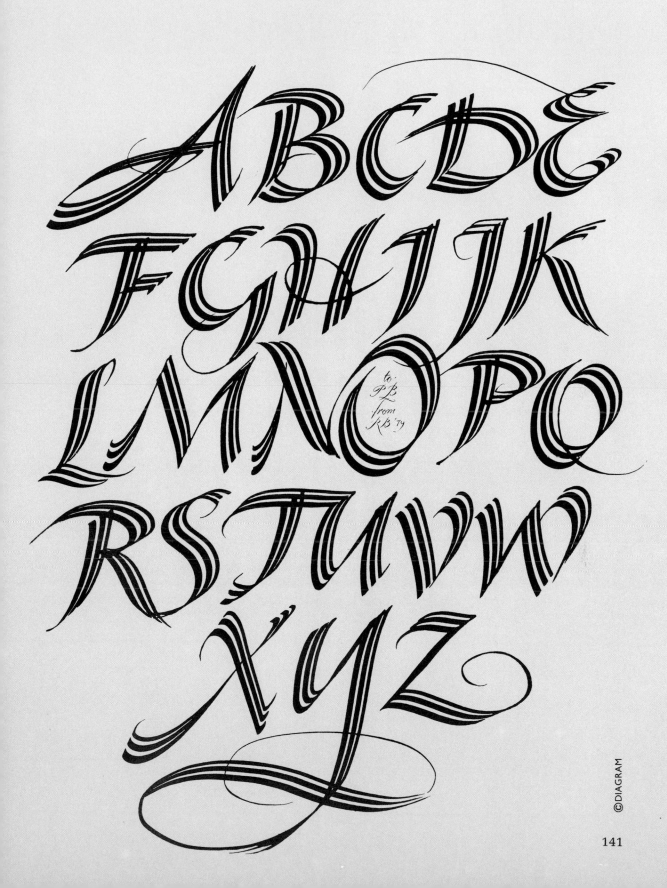

to:
P.B
from
R.B '79

# unusual calligraphic alphabets

This alphabet design by Gaynor Goffe was written with ink on layout paper. The letters are 2.5cm (1″) × height. The flourished Italic capitals (*right*) were written on an A3 sheet as a demonstration to students during a short calligraphy course.

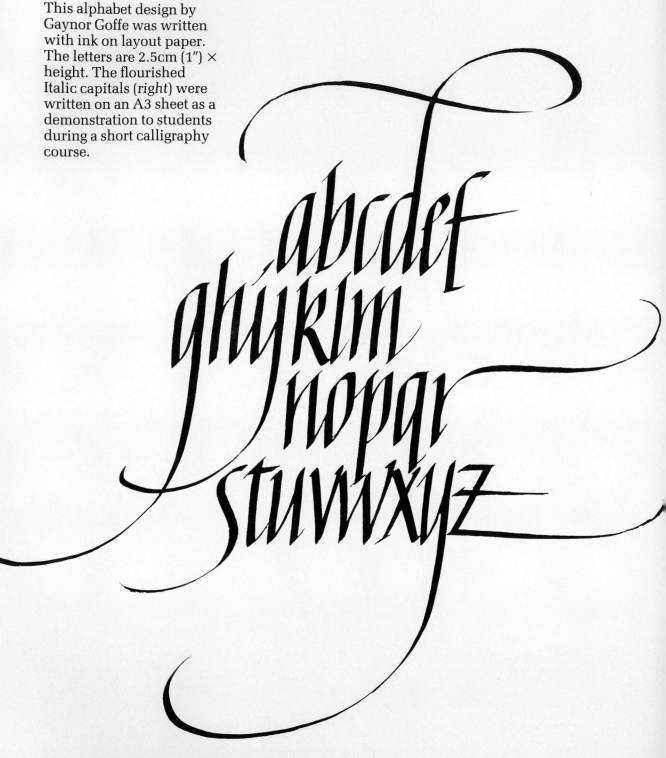

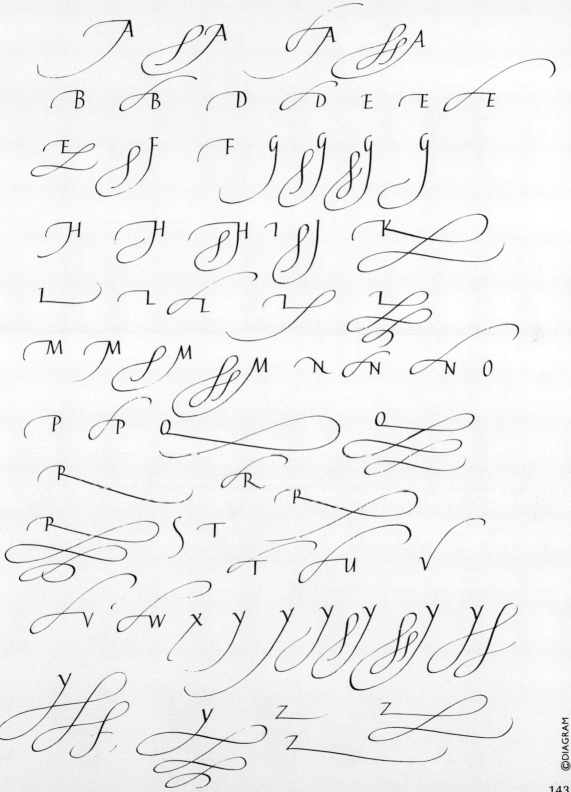

# unusual calligraphic alphabets

This Neuland alphabet is based on Rudolph Koch's wood block letters. It is easy to do. The pen is kept flat and the pull strokes strong, except for thin cross-strokes which serve to give space and light relief. It is best used with a mixture of ink and inky water to alleviate the black or various tones of colour.

A B C D
E F G
H I J K L
M N O
P Q R S
T U U V
W X Y Z

A B C D
E F G
H I J K L
M N O
P Q R S
T U U V
W X Y Z

144

# THE VICTORIA & ALBERT MUSEUM

# NEULAND

**Characteristics**
The hairline space in between some letters is echoed in the linespacing and in the thin black lines of the alternative cross-strokes.

TEH

| 1 | | 1 | | | 1 |

©DIAGRAM

145

# Part Five

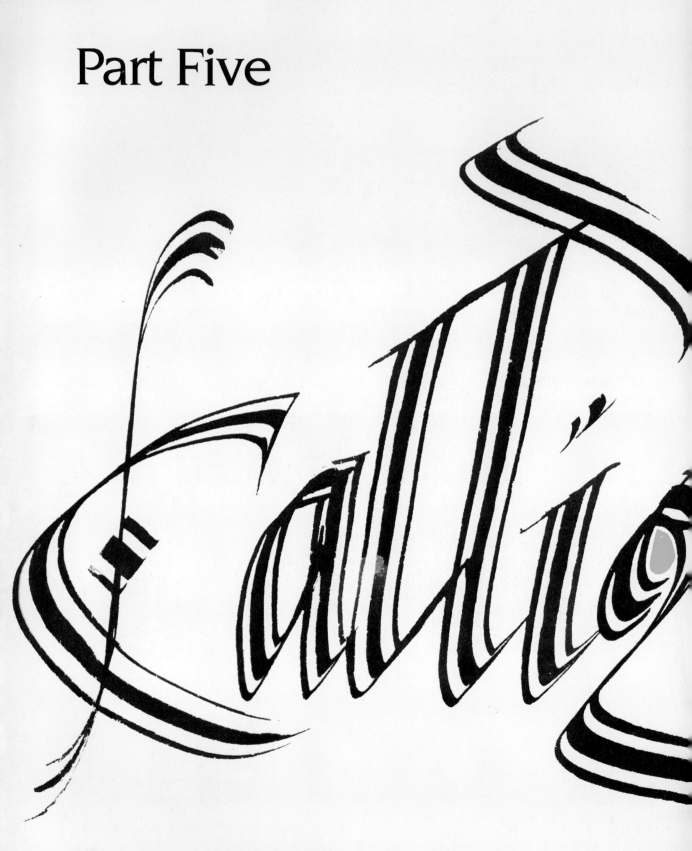

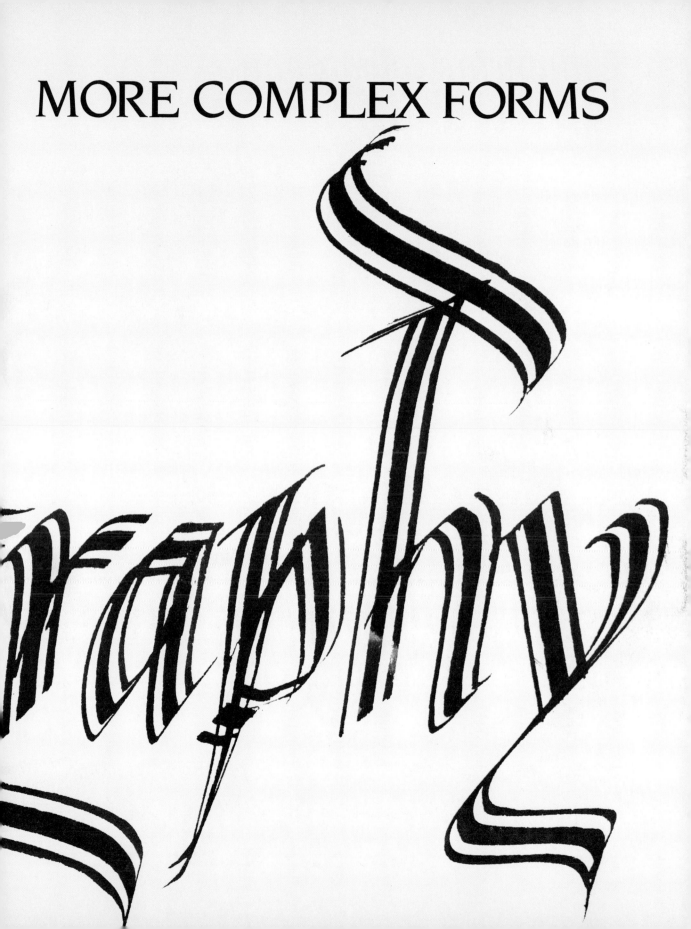

# Enhancing calligraphy

Even with the most straightforward calligraphy, you can find ways of enhancing your designs so that they have that element of real style about them. On these pages we show a few of the elements that can lift your lettering from being ordinary to looking inspired.

**Split-nib pens**
Many of the letterforms that are made with broad-nibbed pens can, for extra effect, be made with split-nibbed pens of varying widths. This technique can be used for a whole piece of lettering, an initial letter or a capital letter in a name.

## Double-stroke lettering

Some of the more complex letterforms can be formed with two strokes. Of course this is already true of many of the Gothic capitals, and also of Versal letters, but other more simple forms can be embellished by drawing the strokes in two parts. The two strokes can be the same width as each other, or contrasting widths.

©DIAGRAM

## Colour

Colour doesn't have to be reserved only for illuminated capitals. You can do some or all of your piece of lettering in a different colour, or do all the capitals a different colour from the small letters. You can pick out particular words in one or more colours, or you can add coloured elements to all or most of the letters.

# enhancing calligraphy

**Complex letterforms**
Capitals in particular lend themselves to very complex forms in calligraphy – although you will need to practise hard to obtain some of the very regular strokes and swashes shown here!

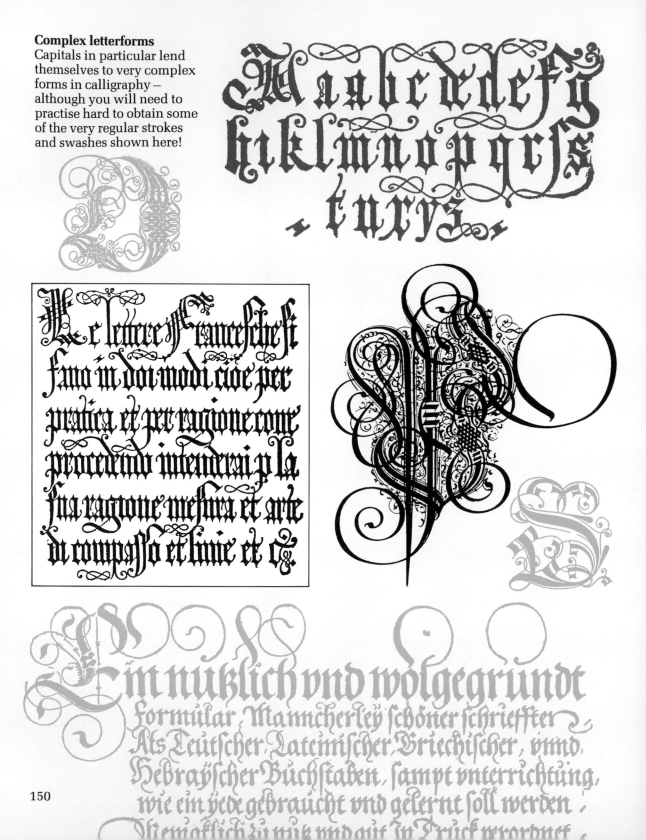

## Surprises

One of the most creative elements that you can build into your calligraphy is the element of surprise. This can take many forms – introducing a movement, a motif, a small picture, an unexpected idea, a very different letterform. On this page there are several examples of this surprise element; use a few pages in your sketchbook to scribble down some ideas for others. Try missing out part of the letter; introducing a motif instead of a letter; using some expressive lettering; using a large capital in an unexpected place; mixing two letterforms; combining two letters; forming a letter in an unusual way; reversing a letter.

Tommy

MIRROR

A flo shell azd9ehs shegdzv stehs 0stV z rmg4zsliedi4t nzits varbdiwdnd derbel4.

© DIAGRAM

# Changing shape and size

Once you have chosen a particular lettering face, you may feel that you are limited by its size, its shape, or its own characteristic 'feel' – whether it is fine or bold, straight or slanted, etc. However, there is nothing to prevent you from altering one or more of these characteristics to suit your own project. In fact learning to enlarge and reduce, expand and contract, slope and slant different letterforms is very good practice for gaining real confidence in handling different types of lettering. Use the practice exercises on these pages to improve your skills; you will soon develop a good eye for judging, for instance, how large a particular face can be blown up before it loses its attractiveness, or just what degree of slant looks right for another letterform.

**Enlarging and reducing**
If you want to enlarge a letterform just a small amount, simply draw your guidelines further apart, and select a suitably larger sized pen or brush. Make sure that you keep the lines in the same ratio to one another (**1**). If you want to make a much greater enlargement, draw a grid over the original form or a tracing of it (**2**). Then draw a similar grid larger (**3**) and fill in the different parts of the letter.
For reducing, use the same principles outlined above but in reverse (**4**).

**Slanting**
Letters can be slanted either to the right (forward) or to the left (backward). The trick is to make sure that all the letters are slanted to the same degree. Letterforms vary in the amount of slant they can take before they look absurd; practise in your sketchbook slanting various faces forward and backward at different angles.

## Expanding

When you expand a letterform you change the ratio of its width to its height, giving it a more squashed appearance. Some letterforms lend themselves very well to expanded versions – others lose their attractiveness. Take several letterforms and expand them to different degrees; see at what stage they lose their individuality.

## Condensing

Condensing letterforms means contracting their width so that the letters are narrower in relation to their height. Condensed forms can look very elegant; some letterforms are already very condensed in their design as a deliberate feature. In your sketchbook contract a selection of different letterforms to different extents; how narrow can they become and still remain legible?

## Making bolder

If you make a letter bolder, you change the internal ratio of its strokes; you make them thicker in relation to the letter's size. Making a letter bolder gives it more appearance of weight; some letterforms, such as Gothic, are already very bold. However, this technique needs to be used with care; the bolder a letter becomes, the easier it is to lose some of the fine details that give the letter its character. Experiment with different faces; where a letter has fine serifs and hairlines, try making those bolder too, and also try just thickening up the wider strokes and leaving the finer ones as they are.

153

# Elaborating on basic forms

As well as changing the size and shape of a particular letter, you can also alter its appearance by adding several elements to the basic form. On these pages we show just a few of the many variations you can impose on different letterforms.

## Starting point (1)
Start off with a basic word in a simple letterform, such as the word shown here. Then try all the methods suggested on these pages for elaborating it, and also form your own combinations – for instance, an outline form with a drop shadow, or a patterned letter from a different angle.

## Reversing (2)
Reversing the letterforms is really a gimmick – the legibility certainly suffers! It can be surprisingly difficult too, as it's hard to remember which way the strokes and the stress go.

## Reversing out (3)
If you put a pale letter on a dark background, rather than the more usual way round of a dark letter on a pale background, this is called reversing out.

## Outlining
You may choose to do a letter purely in outline form (**4**). Or you could combine an outline with a letter in a different colour (**5**), or form an outline of one or more lines (**6**):

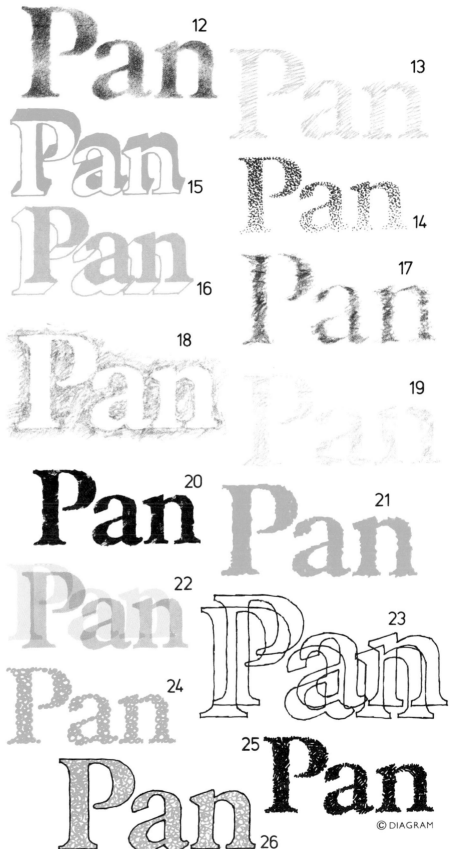

## Shadows

You can add shadows to letters in various different ways; with so-called drop shadows at different angles (**7**, **8** and **9**), and also by just drawing the shadow and allowing this to suggest the shape of the letter (**10**, **11**).

## Shading (12, 13, 14)

Shading the letters in various ways with pencil, brush or pen strokes can suggest letters with different shapes or qualities.

## Angles (15, 16)

Try adding shadows and lines so that it seems as though you are looking at the letters from a different angle.

## Suggesting shapes (17, 18, 19)

The shape of the letter may be hinted at rather than fully drawn in detail.

## Broken edges (20, 21)

If you make the edges of the letters somewhat erratic, this can suggest age, or the idea of having been formed with a rubber stamp.

## Superimposing (22, 23)

Superimposing double or multiple images of the same letters can be very dramatic.

## Patterned (24, 25, 26)

Letters can be patterned, for instance with dots, stripes and other textures, and by having pictures drawn within the shape of the letters.

© DIAGRAM

155

# Expressive lettering

The way you do your lettering can in itself be part of the message you want to put across. The actual letterform you work with can be chosen to enhance what you are trying to say; the technique of the lettering 'expresses' a meaning itself. On these pages we have given you some samples of techniques that can be used to form or change the letterforms in such a way that they give an added meaning, or expression, to the word. Don't forget the possible use of colour; cool colours such as blue and white suggest cold, while warm ones such as red and orange suggest heat. Colours can be used to conjure up a particular image instantly.

**1** Dry brush over a rough surface.
**2** Pentel; in style of early Greek inscriptions.
**3** Active brush marks.
**4** Assembled letters from a variety of sources.
**5** Flat edge of crayon over coarse-grained paper.
**6** Type letters cut up and reassembled.
**7** Regular geometric shapes made up of dots.
**8** Thin ink drawing; use a drinking straw to blow at the shapes while they are still wet.
**9** Thick paint dragged over paper.
**10** Letters made from other elements; brickwork in this instance.
**11** Comic book style letters drawn to represent display metal characters.
**12** Stencil style.
**13** Heavily inked fat brush forms, changing from upper to lower case.
**14** Adaptation of one letter to imply another meaning.
**15** Graffiti style lettering.
**16** Speed style.

156

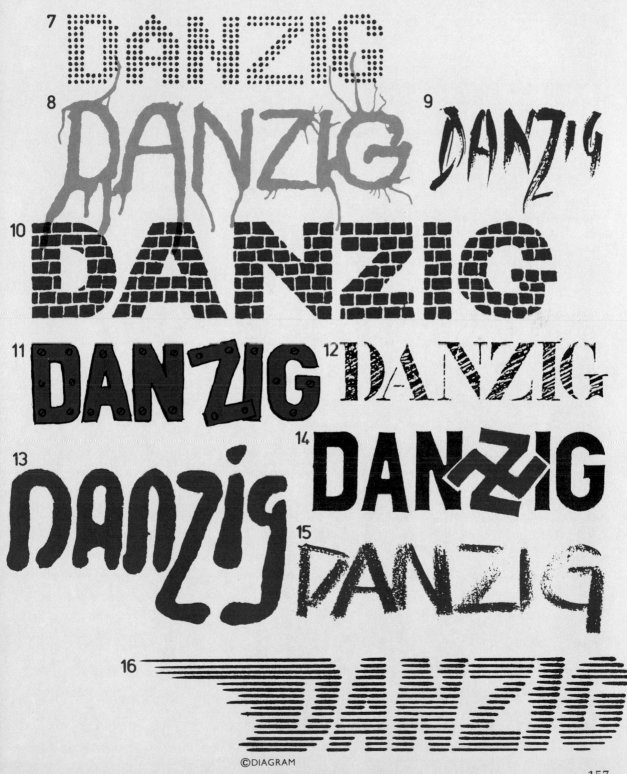

7 DANZIG
8 DANZIG 9 DANZIG
10 DANZIG
11 DANZIG 12 DANZIG
13 DANZIG 14 DANZIG
15 DANZIG
16 DANZIG

# Imitating letterforms

Even the most complicated letterforms can be imitated once you have developed a good eye for detail. Study carefully all the characteristics of the chosen face, whether it is calligraphic, printed, brushed or even designed by computer. You will soon learn to pick out the important characteristics that make that letterform unique, and imitate them in your chosen medium.

### Stress varieties
Stress will give you a vital key to reproducing a particular lettering face; find out the angle of the thickest possible line to find the direction of the stress. The faces shown here have stresses in different directions.

### Variety of forms
Letterforms can range from the very basic to the totally bizarre! Shown here are several of the most unusual letterforms from different eras.

### Angularity
Angularity is another important characteristic of lettering; is the alphabet rounded, chiselled, angular, based on circles or V-shapes? The examples here show the letter O with differing degrees of angularity.

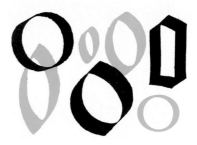

### Slant
Slant will give many lettering faces their particular bias. Are the characters upright, or slanted to the right or to the left? If they are slanted, how exaggerated is the angle? Are all the letters slanted to the same degree?

### Line strengths

Watch out for the relationships between the thick and thin lines; are all the lines of the same thickness, or are some thicker? If there is variation, how great is it? Precisely which lines, for instance on an m or a w, are thick?

### Ends of letter shapes

Serifs are the extra decorations at the ends of the strokes of the letters. Serifs can come in many shapes and forms, or be missing altogether; letters without serifs are known as sans serif characters. The examples here show some of the many ways of using serifs.

### Capital characters

Capitals can have enormous variation among different faces. Here is a selection of capital As from different lettering styles; it's difficult to believe that they are all the same letter!

### Identifying lower case characters

Lower case letters may need closer observation to check on a face's unique characteristics. The lower case g is always a good letter to observe – the variations can be very great, as these examples show.

# Designing an alphabet

Designing an alphabet can be great fun. You can either experiment with a style of lettering until you arrive at unique forms, or you can superimpose conditions on your alphabet; a strong grid, strong emphasis of strokes, common forms or particular characteristics.

You will quickly discover that some letters are more difficult to resolve and make into a family of shapes similar to others.

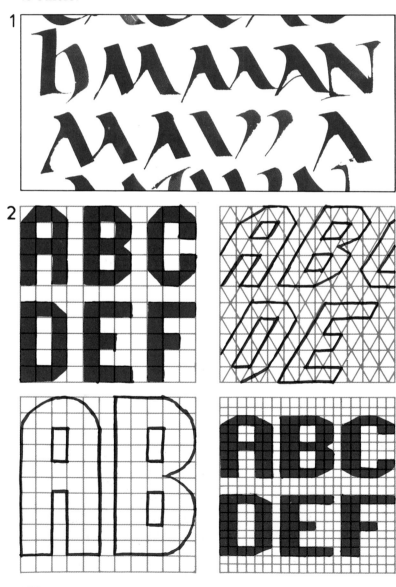

**Letter shapes**
Alphabets come in all shapes and styles. The letters (*above right*) are selected from note sheets and reproduced actual size.

**1  Exploring forms**
As you become more proficient, you can begin to explore the varieties of shapes produced by the pen. Try to discover new forms and retain these as part of your own personal variants. Remember to work quickly and confidently to achieve a free flowing line.

**2  Superimposing structures**
By using grids, you can construct a wide variety of alphabets. The grid method offers controlling factors such as size of grid to forms, angle of grid and how you interpret the grid. You can build up shapes as building blocks, distort or slant the letters, include rounded forms or vary the horizontal and vertical elements.

**3  Transformation of an alphabet**
You can begin with any alphabet, for example Gothic, and work over the shapes with tracing paper. Overdraw varieties of shapes and each solution should resolve the shapes into a new form as you progress.

**4  Character adaptation**
By selecting an alphabet close to the one you wish to use for a particular design, for instance Lombardic, you can experiment with exaggerating its features. Try using a different tool, either thicker or thinner than the original.

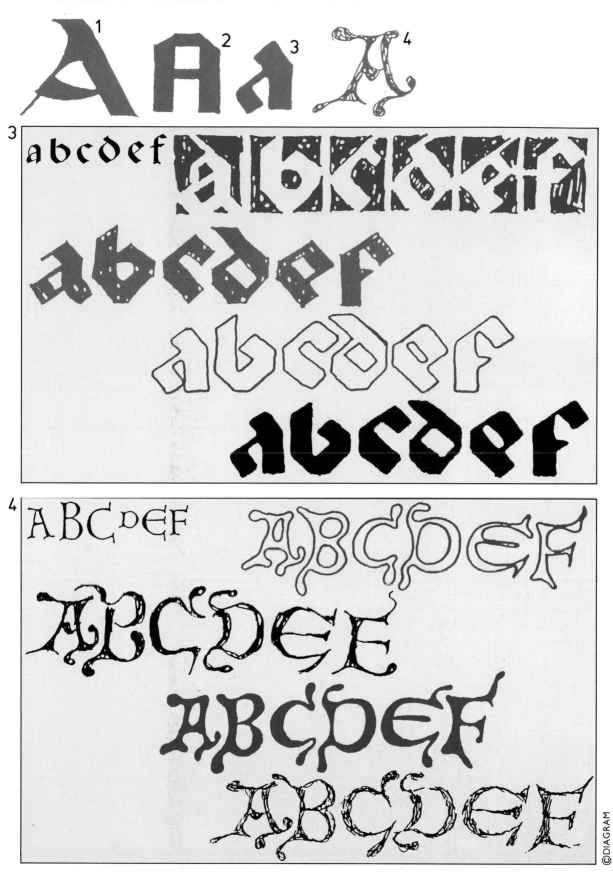

# Part Six

# FINISHING TOUCHES

ristmas

ew year

reetings

# Illuminating

Illuminating is the art of decorating letters with all kinds of motif – patterns, pictures, lines, shading, highlighting, gilding, etc. True gilding is a very specialised subject, involving the application of tissue-thin layers of gold leaf over a layer of sticky glair, but the effect of gilding can be imitated with many of the fine-quality metallic inks and paints that are available today. Silver and bronze colours can be used as well as gold, and metallic paints and inks in other colours can sometimes be obtained. You can decorate a letter in almost any way you can think of. Don't worry about whether you are doing it the 'right' way or not; when you look at the wealth of examples of illumination from past centuries, you will realise that there is no set design to follow. Illumination is one of the best chances for you to use your own imagination and creativity. Don't be tied to just the conventional tools and materials either; experiment with brushes, pens, felt pens, spray paints, airbrushes, rub-down motifs, etc. Be bold and imaginative in your designs and your use of colour – don't be afraid to show off your skills through illumination, because that's exactly what the monks were doing when they first began the art of decorating letters! Illumination is all about flamboyance.

### Bits and pieces...
One of the simplest ways to decorate letters is to add fine lines of colour, dots, or decorative strokes to the basic letterform.

### Pictures
Large letters can be used as showcases for miniature illustrations; this device was very common in mediaeval manuscripts. Flowers, birds, animals, people, or whole scenes from life can be incorporated into your design.

### Changing the letterform
If you are using a large initial letter or drop capital, this may be an ideal time to alter the formation of the letter itself, for instance with internal twists, knots, extra curves, or shading to give a three-dimensional appearance.

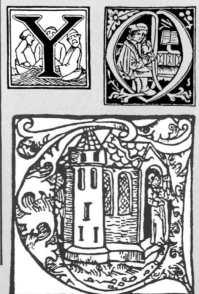

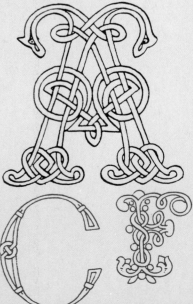

## Progressive illumination

This exercise shows how a basic letterform can be illuminated by adding more and more different elements – shading, outlining, blocks of colour, pattern, etc. Try a similar exercise in your sketchbook, taking various letters in differing styles and adding progressively more ornamentation.

## Patterns on the letter

You can change the texture of the letter by covering the surface with a pattern; this may be as simple as straight shading strokes, or as complex as some of the highly twisted knot designs seen in Celtic letters.

## Patterns behind

You can provide contrast for a plain letter by creating a pattern behind it, so throwing the main letterform into relief. The pattern can be ultra-traditional or ultra-modern, very simple or highly ornate.

## Not what it seems...

One idea that has been used in both ancient and modern lettering is to form the shape of a letter from completely different elements, for example, people, animals, tools, ribbon – even from pictures of food!

©DIAGRAM

# *illuminating*

## Creating patterns

Thinking up patterns can be one of the hardest parts of illuminating a letter. Choose a letter and take a page or two in your notebook to try out as many different simple patterns as you can think of, both behind and on the letter. The ideas here will start you off; see how many others you can come up with in about 15 minutes. Then try again with another letter.

**Variety**

Letters can be illuminated in almost any way, plain or decorative; these examples show just some of the many thousands of ways of decorating a basic letterform!

167

# Oriental decoration

It is very easy to give your calligraphy and lettering an oriental flavour by adding eastern decoration to it; this way of embellishing your work will look particularly convincing with brush lettering, as that looks more eastern and less precise than pen lettering. Oriental designs are generally asymmetrical and very simple, so remember this when constructing your original design. The art of oriental decoration is to make the illustrations or other effects look as artless and effortless as possible – a few simple shapes perfectly positioned here and there. Once again, this sounds a lot easier than it is! If you want some inspiration for the right effect, find some books on ikebana, the Japanese art of flower arranging; this will demonstrate just the sort of minimal design that you should be aiming for.

**Flower**
This simple flower shape (*above*) shows how easily an oriental decoration is constructed – just a series of strokes radiating out from the centre at different lengths.

**Brush strokes**
There are four different brush strokes that you can use to produce this kind of decoration for your lettering.
**1** The brush is held as shown and moved vertically up the paper.
**2** The brush is held at a backwards angle and moved away from you.
**3** The brush is held so that your thumb guides it upwards.
**4** The brush is grasped along the shaft and moved across and down.
Practise the different effects until you feel confident about producing each one.

**Stroke length** (*below*)
The length of your brush stroke will be critical in producing the shapes of petals, stems, leaves, etc.
**1** Short stroke
**2** Medium-length stroke
**3** Long stroke

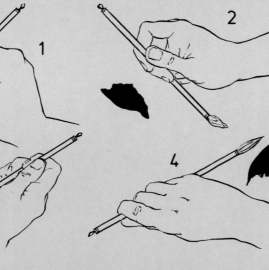

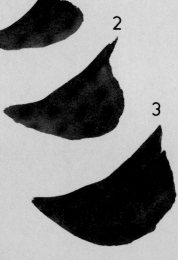

**Additional strokes** (*below*)
Often you will want to do a
base wash in one colour and
then add detail in a darker or
contrasting colour on top.
You need to do this before
the wash colour dries out so
that the two colours blend
together pleasingly. In (**1**)
the base was too dry so that
the lines look scratchy; in (**2**)
it was too wet, so the lines
have blurred too much. In (**3**)
the mixture was just right to
blend the colours.

**Creating different textures**
Work in the way described
to practise each of these
textures; try using brushes of
different lengths and
thicknesses, and notice how
the strokes and final effects
change.
**1** Long speckles of colour
made with a well-loaded
brush laid sideways on the
paper.
**2** Pinpoints formed with the
tip of the brush held
vertically.

**3** Cobblestone effects formed
horizontally and vertically.
**4** Small clumps of foliage,
growing upwards and
downwards.
**5** Star-patterned foliage,
formed in the same way but
with different amounts of
ink on the brush and at
different speeds.
**6** Texturing lines, straight
and angled.
**7** Foliage formations.
**8** Different kinds of blossom.

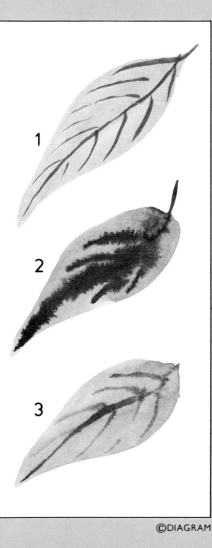

©DIAGRAM

# Borders and Fillers

### Borders and fillers
Decorative borders and line fillers are a very beautiful way of enclosing and giving style to your calligraphy and lettering. You can draw them yourself with a pen or brush. If you are doing a very special piece of calligraphy try always to do the borders in a complementary style. They should not be too heavy to detract from the lettering or too light so they do not blend in with the text. On these pages we show just some of the many ways you can experiment with; even the plainest line borders can have fancy corners added for extra detail.

### Simple borders
Take a grid and experiment by building up patterns. The example (*below*) shows some finished results.

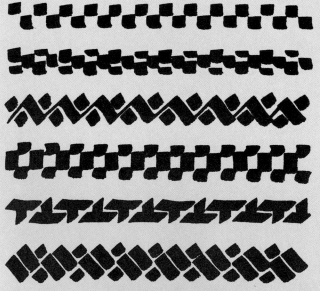

**Practice exercises**
The example (*left* and *above*)
shows the different stages in
the development of a border
and the final square. The
variations (*left*) show how
you can use letterforms,
individual strokes or circles
to form patterns.

# borders and fillers

### Line fillers

Line fillers have always been used historically to fill gaps on a page of writing. The examples (*below*) show extra flourishes at the end of lines. As decoration became more flashy the fillers were often little drawings used individually or as part of a pattern. Some of the variations are shown on these pages.

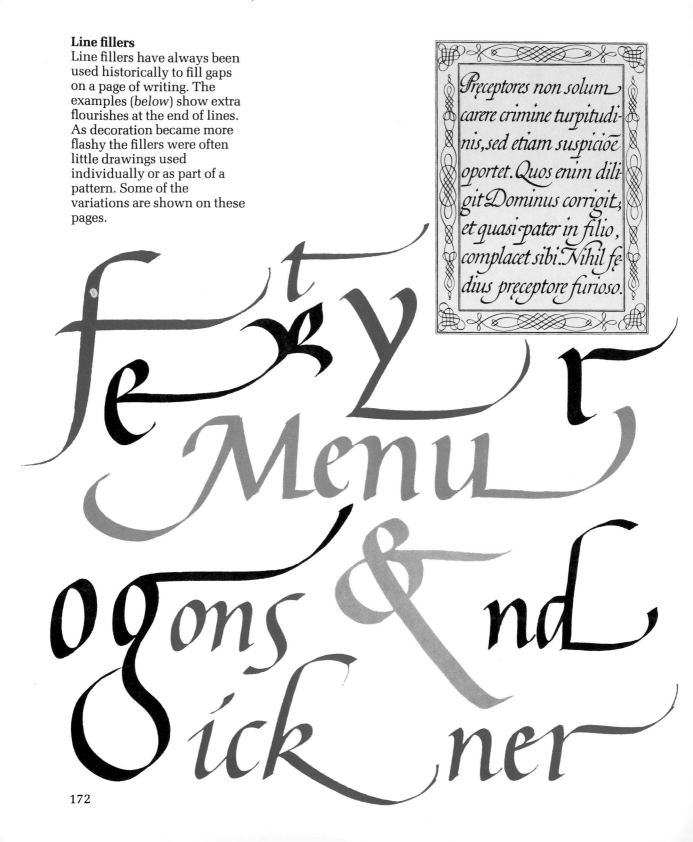

Preceptores non solum
carere crimine turpitudi-
nis, sed etiam suspicioē
oportet. Quos enim dili-
git Dominus corrigit,
et quasi pater in filio,
complacet sibi. Nihil fe
dius preceptore furioso.

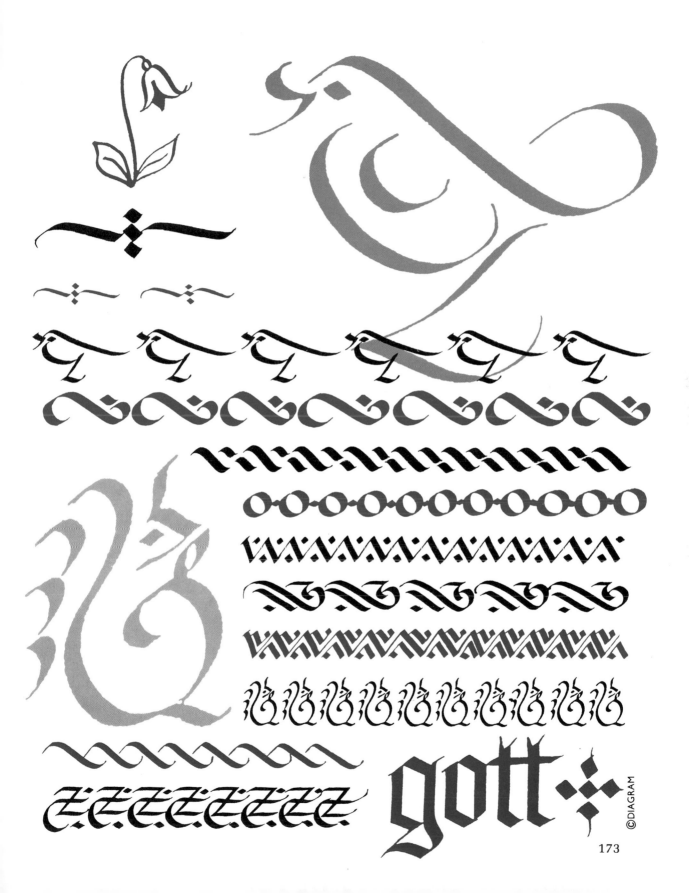

gott

# Stationery

Beautifully-lettered stationery can be produced in one of two ways. Either you can letter each piece individually, or you can do one piece of good lettering and have it printed. Individually written pieces are appropriate for things such as jam and preserve labels, home-made wine labels, individualised cards, and place-names for special meals. For small parties, you can also letter up each invitation or menu by hand. If you want lots of sheets of writing paper, Christmas cards, business cards or invitations, you will need to have them printed from an original piece of lettering. The master for printed calligraphy should be done in black ink on crisp white paper, regardless of the colour of the ink or paper used for printing; the strong contrast between the black and the white makes the printer's job easier when he has to make the printing plate. Your stationery can of course be decorated with motifs, borders and illustrations as well as calligraphy.

**Stationery examples**
Shown here are a few examples of the ways in which good lettering can be used for attractive stationery.

INVITATION
You are invited

seasons greetings
merry christmas
happy new year

OREGANO

M·U·L·B·E·R·R·Y
W·I·N·E
1·9·8·5

Thank you

THIS BOOK BELONGS TO david

GINGER
MARMALADE

OAKWOOD
B·A·K·E·R·Y
HIGH ST
THORNHILL
DUMFRIES

MERRYCHRISTMASTOYOUMERRYC
YOUMERRYCHRISTMASTOYOUM
MERRYCHRISTMAS TO YOUMERI
TO YOUMERRYCHRISTMASMER
MERRYCHRISTMASTO YOU MER
RYCHRISTMASTOYOUM

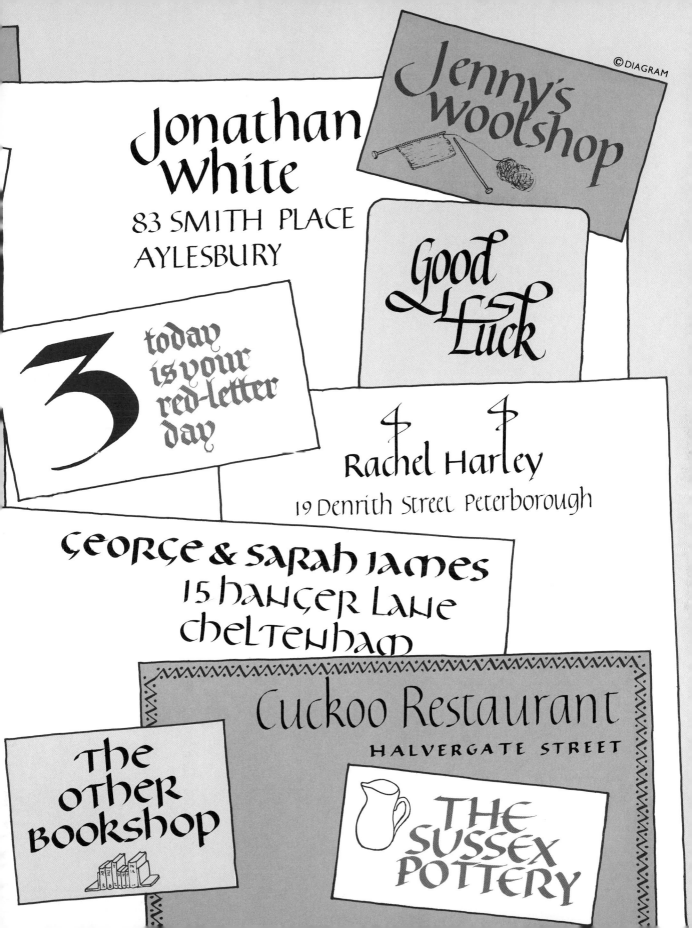

Jonathan White
83 SMITH PLACE
AYLESBURY

Jenny's Woolshop

Good Luck

3 today is your red-letter day

Rachel Harley
19 Denrith Street Peterborough

George & Sarah James
15 Hanger Lane
Cheltenham

The Other Bookshop

Cuckoo Restaurant
HALVERGATE STREET

THE SUSSEX POTTERY

©DIAGRAM

# Pictures, panels and maps

Calligraphy and lettering can be used to enhance all kinds of designs; you can either make the main decorative element the lettering itself, or you can add appropriate letterforms to complete a design. Designs with strong curves or outlines, such as maps or medallion shapes, may lend themselves to having the lettering moulded around the lines of the design rather than being done in straight lines. These pages show just a few of the many ways that letterforms can be incorporated into pictures and decorative panels.

177

# Monograms and logos

Monograms and logos are excellent ways of personalising a particular set of initials. Generally, monograms are made up of various letters in the same style or face, arranged together in a pleasing pattern. Logos are more on the commercial side, often used as identities for companies and organisations. Both monograms and logos can be formed from upper or lower case letters. Some letters that are very difficult to put together pleasingly in capitals, for instance, A and J may look better in lower case; with other letter combinations the opposite may be true.

**Combining letters**
Letters may be combined by joining them up, by placing them very close to one another, by arranging them in an obvious pattern, by linking them with a picture or motif, by intertwining them, and in many other ways. These examples show logos of many different kinds.

**Different styles**

There is no limit to the various ways that you can combine two or more letters, and the different styles and 'flavours' that you can use. These examples show the two letters S and R combined in several very different ways. Do a similar exercise in your sketchbook with your own initials, or with any other suitable combination of letters. See how many different styles you can evoke by varying the letterform and what you do with it.

© DIAGRAM

**Practice rules**

Lindsay Cobb

**Foundational** using Osmiroid B4 fountain pen

Oabj

**Foundational** using Osmiroid B3 fountain pen

Oabj

**Basic Italic** using Osmiroid B4 fountain pen

**Italic** 5° slant

**Basic Gothic** using Osmiroid B4 fountain pen

𝖮𝖺𝖇𝖏

**Roundhand and copperplate**

# Glossary

**Alignment** – an arrangement of lines of lettering in relation to their margins

**Alphabet** – the full range of different letters used in any particular writing tradition

**Ascenders** – the parts of lower case letters extending above the x height

**Baseline** – the lower guideline of a letter's x height

**Bold letter** – one whose strokes are thick compared with its height

**Capitals** – upper case letters used to begin a sentence or a name; majuscules

**Centred** – lines of lettering arranged around a symmetrical axis

**Character** – any letter, punctuation mark or other typographic symbol

**Condensed letterform** – one whose width is narrow compared with its height

**Counter** – the space enclosed or defined by the curve or stroke of a letter

**Cross-strokes** – horizontal or near-horizontal lines in a letter

**Descenders** – the parts of lower case letters extending below the x height

**Drop capital** – a capital letter placed so that it eats into lines of lettering below it

**Drop shadow** – shading added to letterforms to make them appear three-dimensional

**Elbow nib** – an angled nib used for copperplate writing

**Expanded letterform** – one whose width is wide compared with its height

**Expressive lettering** – lettering done in a style which reflects its meaning

**Finish** – the final smoothing of a paper surface

**Fountain pen** – a pen with a hollow barrel that holds a considerable amount of ink

**Gilding** – applying gold leaf to lettering to decorate it

**Guidelines** – faint lines drawn to help the calligrapher to do an even line of lettering

**Hairlines** – fine lines used as part of a letterform

**Highlighting** – emphasising certain features of lettering with colour or decoration

**Illumination** – complex decoration of letterforms with colour and design

**Indent** – an extra space left at the beginning of a line of lettering

**Initial letter** – an extra-large letter at the beginning of a piece of work

**Justified** – lines of lettering that have even margins at the right and left-hand edges

**Layout** – the arrangement of design elements on a page or paper

**Letterfitting** – the way in

188

which adjoining letters relate to each other
**Letterspacing** – the gap between two letters in a word
**Light letterform** – one whose strokes are fine compared with its height
**Linespacing** – the amount of space between lines of lettering
**Logo** – an arrangement of two or more letters, generally used as a commercial symbol
**Lower case** – a small or minuscule letter

**Majuscule** – a capital or upper case letter
**Manuscript** – a piece of lettering written by hand rather than printed
**Margins** – the borders of paper left around areas of lettering
**Metallic inks** – inks with small shiny particles in suspension
**Minuscule** – a small or lower case letter
**Monogram** – a decorative arrangement of one or more letters, usually initials

**Ornamentation** – decoration of a letterform or piece of lettering

**Papyrus** – early form of writing surface made from reeds
**Parchment** – inner skins of sheep or pigs, prepared for writing
**Pigments** – colouring agents

**Quill** – pen made from a feather shaft

**Ranged left** – lines of writing with an equal left-hand margin
**Ranged right** – lines of writing with an equal right-hand margin
**Reversed out** – lettering worked light on dark rather than dark on light

**Serif** – decorative ending to the stroke of a letter
**Signwriting** – lettering on a large scale, usually for commercial purposes
**Slant** – the angle at which a letterform leans away from the vertical
**Spread** – two pages of a book seen together

**Stick ink** – pigment in solid form that has to be ground in water before use
**Stress** – the angle of the thickest stroke of a letterform
**Swash** – a decorative line added to a letter

**Upper case** – a capital or majuscule letter

**Vellum** – calfskin prepared as a writing surface
**Visual spacing** – letterspacing worked aesthetically rather than by rigid rules

**Weight** – the thickness of a letterform in relation to its height
**Wordspacing** – the space allowed between individual words in lettering or calligraphy

**X height** – the height of the body of a lower case letter, excluding ascenders or descenders

# Index

# *index*